Willie Doherty

Willie Doherty

Anthologie zeitbasierter Arbeiten

Anthology of Time-Based Works

Herausgegeben von Edited by
Yilmaz Dziewior und and Matthias Mühling

Mit Beiträgen von With contributions by
Yilmaz Dziewior
Francis McKee
Matthias Mühling

Inhalt Contents

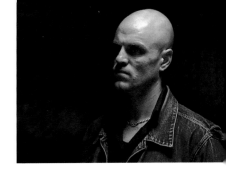

Vorwort

Diese Publikation erscheint anlässlich der Ausstellung von Willie Doherty im Kunstverein in Hamburg und in der Städtischen Galerie im Lenbachhaus und Kunstbau in München. Es handelt sich dabei um die erste umfassende Retrospektive seines zeitbasierten Werks in Deutschland. Willie Doherty, 1959 in Derry, Nordirland, geboren, zählt zu den bekanntesten Künstlern seiner Generation. Seit den 1990er-Jahren sind seine Arbeiten in unzähligen internationalen Ausstellungen präsent. Eine große Einzelausstellung, die sich zur Aufgabe gemacht hat, die Kontinuität und spezifische Qualität seines filmischen Werks aufzuzeigen, hat es aber bisher noch nicht gegeben. Um die beeindruckende Entwicklung seines Œuvre angemessen zu würdigen, haben der Kunstverein in Hamburg und das Lenbachhaus in München zwei unterschiedliche, sich ergänzende Ausstellungen entwickelt, die zusammen einen repräsentativen Überblick über die Diainstallationen und Videoarbeiten vom Anfang der 1990er-Jahre bis heute ermöglichen. Die begleitende Publikation stellt mit einem vollständigen Werkkatalog aller Filme und Diainstallationen nicht nur den Ausstellungskatalog dar, sondern kann über den Anlass der Präsentation hinaus als wissenschaftliches Nachschlagewerk dienen. Vielleicht ist sie auch ein Ansporn, die fotografischen Arbeiten des Künstlers ebenfalls umfassend aufzuarbeiten.

Seine Ein- oder Mehrkanalvideos, die Willie Doherty häufig raumgreifend präsentiert, entwerfen politische und ästhetische Bilder von Irland, die der weit verbreiteten Vorstellung einer schönen unberührten Naturlandschaft ebenso kritisch gegenüberstehen wie einer einseitigen Berichterstattung über den Nordirlandkonflikt. So wechseln beispielsweise die bei einigen Arbeiten über die Bilder gelegten Stimmen aus dem Off ihre Identitäten und verwandeln sich abwechselnd von Täter zu Opfer und umgekehrt. Es geht dem Künstler weniger um eine fixierte Deutung und Festschreibung der Ereignisse als vielmehr darum, die archetypischen Merkmale des Konflikts präzise zu benennen. Dies wird auch in den filmisch festgehaltenen Spuren der Unruhen – wie zum Beispiel verlassenen, verwüsteten Gebäuden oder Straßensperren – deutlich, die stets als ambivalente Phänomene aufgefasst werden. Das heißt, sie werden sowohl als Auslöser wie auch als Ergebnis von Handlungen begriffen. Dieser perspektivische Rollentausch korrespondiert mit der Rezeption der von Willie Doherty häufig dualistisch konzipierten Arbeiten, die nur dann optimal wahrgenommen werden können, wenn sich die Besucher im Raum bewegen und sich abwechselnd einer von zwei Projektionsflächen zuwenden. Eine besondere Qualität der Arbeiten Dohertys liegt in ihrem Potenzial, über den konkreten Konflikt in Nordirland hinaus unterschwellig auch Themen wie die Überwachung öffentlicher Plätze, Ein- und Ausschlussmechanismen sowie National- und Religionskonflikte auf allgemeingültiger Ebene differenziert zu verhandeln. Seine Videoarbeiten loten im Spannungsfeld von Authentizität und Fiktion die Möglichkeiten und Bedingungen des filmischen Apparats aus und nutzen Merkmale von so unterschiedlichen Genres wie Action-, Dokumentar- und Autorenfilm. Auch wenn Willie Dohertys variierende stilistische Mittel ein breites Spektrum aufweisen, so ist allen seinen Arbeiten nicht

nur ein hohes Maß an suggestiver Bildfindung eigen, sie bestechen immer auch durch die Ambivalenz des scheinbar Eindeutigen. Eine bedrohlich wirkende Person wie beispielsweise der kahlköpfige Mann in *Non-Specific Threat* (2004, S. 136 ff.), der langsam in einer Kamerafahrt umrundet wird, charakterisiert sich mit den aus dem Off gesprochenen Worten gleichermaßen als agierend wie reagierend, als Fiktion und Realität, als Vergangenheit und Zukunft. In seinen Worten wechseln Szenarien der Bedrohung mit solchen der Intimität. Dieser Mann könnte sowohl ein möglicher Beteiligter des Nordirlandkonflikts, ein Terrorist oder aber auch Repräsentant staatlicher Macht sein. Genauso gut besteht die Möglichkeit, ihn als ganz gewöhnlichen Menschen, als Arbeiter, Studenten oder Sportler zu deuten.

Gerade diese produktive Uneindeutigkeit verwickelt die Betrachter nicht nur emotional, sondern auch intellektuell und verdeutlicht anschaulich, dass allgemeine, diffuse Ängste vor möglichen Gewalttaten und Projektionen in Bezug auf die Gefährlichkeit von vermeintlich Fremdem nicht nur in Nordirland ein Charakteristikum des allgemeinen Status quo der Gesellschaft darstellen.

In seinem Essay thematisiert Francis McKee die besondere soziale und politische Situation, in der das Werk von Willie Doherty entsteht, und erläutert es vor diesem Hintergrund einfühlsam und kenntnisreich. Ihm und allen anderen am Katalog Beteiligten gilt unser großer Dank. Zu nennen sind hier vor allem auch Gabriele Sabolewski, die den Katalog auf so ansprechende Weise gestaltet hat, und Annette Kulenkampff, die das Buch mit großer Begeisterung in das Programm des Hatje Cantz Verlags aufgenommen hat und somit unsere langjährige fruchtbare Zusammenarbeit fortsetzt.

Für ihre organisatorische Hilfe möchten wir der Galerie Peter Kilchmann in Zürich und Alexander and Bonin in New York danken. Ein derart ambitioniertes Projekt kann nur in der Zusammenarbeit vieler realisiert werden. So gilt unserer aufrichtiger und tiefer Dank unseren engsten Mitarbeiterinnen und Mitarbeitern Meike Behm, Eva Birkenstock und Corinna Koch sowie dem Aufbauteam mit Robert Görß und dem Techniker Andreas Krüger in Hamburg, Susanne Böller, Karin Dotzer, Felix Prinz, Claudia Weber, Jonna Gaertner und Andreas Hofstett in München. Für die reibungslose Planung und Koordinierung der Installationen an beiden Orten zeichnet die langjährige Mitarbeiterin von Willie Doherty, Sue MacDiarmid, verantwortlich. Den Leihgebern Tate in London, The Arts Council Collection in London, The Irish Museum of Modern Art in Dublin und Ingvild Goetz in München sei für die großzügige Bereitstellung der Leihgaben gedankt. Finanzielle Unterstützung erfuhr die Ausstellung durch Culture Ireland und die University of Ulster.

Es ist für uns eine große Ehre und eine wichtige Erfahrung gewesen, das Vertrauen von Willie Doherty zu gewinnen und die Ausstellungen sowie das begleitende Buch gemeinsam mit ihm zu realisieren. Ohne sein kluges und leidenschaftliches Engagement wären Ausstellung und Katalog in dieser Qualität niemals möglich gewesen. Wir möchten ihm deshalb hier noch einmal ganz besonders unseren tiefen Dank aussprechen.

Yilmaz Dziewior

Kunstverein in Hamburg

Matthias Mühling

Städtische Galerie im Lenbachhaus und Kunstbau, München

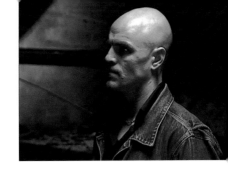

Foreword

The Willie Doherty exhibition at the Hamburg Kunstverein and the Städtische Galerie im Len-
bachhaus and Kunstbau, in Munich, is the first comprehensive exhibition of Doherty's time
based work in Germany. Born in Derry, Northern Ireland, in 1959, Doherty is one of the best-
known artists of his generation and has been chosen to represent his home country at the
Venice Biennale this year. His works have appeared in countless international group exhibitions
since the 1990s.

 This is the first large-scale Doherty solo exhibition of its kind, dedicated to exploring the
underlying continuities and quality of his slide and video work. In order to do justice to the evo-
lution of this impressive oeuvre, the Hamburg Kunstverein and the Lenbachhaus Munich have
developed two different, but complementary exhibitions that give a representative showing of
the slide installations and videos from the start of Doherty's career in the early 1990s to the
present day.

 The accompanying publication, containing an exhaustive oeuvre catalogue of all Doherty's
films and slide installations, is both an exhibition catalogue and a reference tool. One hopes that
it might also inspire a similarly exhaustive treatment of the photographic works.

 In his (often large-scale) single- and multi-channel videos, Doherty offers political and
aesthetic images of Ireland that challenge widespread misconceptions of pristine natural land-
scapes as well as it does biased coverage of the Northern Ireland conflict. The voiceover in cer-
tain works, for instance, switches identity between offender and victim. Doherty's concern is not
so much to tie down events and interpretations as to pinpoint archetypal features of the conflict.
The traces of conflict that the videos capture—for instance, deserted and wrecked buildings, or
roadblocks—are also always viewed ambivalently, both as provocation for and as the conse-
quence of actions. This shifting of perspectives and roles is in keeping with the reception that
Doherty's often dualistically conceived works invite: perception of them is optimal when one
moves around the exhibition space, directing attention at one of two screens, then at the other.

 Doherty's works have a remarkable ability to reach out beyond the specifically Northern
Irish conflict and deal at a sophisticated level with general topics such as the surveillance of
public space, mechanisms of inclusion and exclusion, and national and religious conflicts. Be-
tween the opposing poles of authenticity and fiction, his videos explore the possibilities and
conditions of the filmic apparatus, drawing on genres as various as action film, *Autorenfilm,* and
documentary.

 While Doherty's stylistic devices are wide-ranging, all of his works share a high degree
of suggestive visual invention and also the fascinating ambivalence of what at first sight appears
to be unambiguous. A seemingly ominous figure, such as the man with shaved head in *Non-
Specific Threat* (2004, p. 136), for instance, whom the camera circles to the accompaniment of
a voiceover, is both active and reactive, fictional and real, past and future. His words invoke

situations ranging from menace to intimacy. The man could be a participant in the Northern Ireland conflict, or a terrorist, or for that matter a representative of state power. Or he could also be a plain human being—a worker, a student, a sportsman.

It is precisely this productive ambiguity that implicates the viewer at a level that is not only emotional but also intellectual, and reveals that those fears of possible violence and the paranoiac projections vis-á-vis the supposedly strange and unfamiliar are by no means confined to Northern Ireland.

In his essay Francis McKee knowledgeably and insightfully interprets the work of Willie Doherty against the backdrop of the specific social and political context in which it is situated. Our thanks go to all those involved in the production of the catalogue, in particular to Gabriele Sabolewski, who devoted such care to its design, and Annette Kulenkampff, who enthusiastically included this book in the Hatje Cantz Verlag publishing program, thus perpetuating a long and fruitful collaboration.

We wish to thank the Galerie Peter Kilchmann Zurich and Alexander and Bonin New York for their organizational assistance. A project as ambitious as this would be impossible without the cooperation of a large number of people. In particular we would like to express our profound thanks to our respective teams, to Meike Behm, Eva Birkenstock, Corinna Koch, and the assembly team with Robert Görß and technician Andreas Krüger in Hamburg, and to Susanne Böller, Karin Dotzer, Claudia Weber, Jonna Gaertner, and Andreas Hofstett in Munich. Sue Mac-Diarmid, Willie Doherty's longstanding technical assistant, is responsible for the harmonious planning and coordination of the installations at the two venues.

Our gratitude is extended to Tate Modern, in London, The Arts Council Collection, in London, The Irish Museum of Art, in Dublin and to Ingvild Goetz, in Munich, for generously loaning works. The exhibition received financial support from Culture Ireland and the University of Ulster.

To have won Willie Doherty's trust and support in realizing this publication and the exhibitions together with him has been a great honor and an enrichment. The quality of catalogue and exhibitions is in large part a result of his intense and intelligent involvement. We would therefore like to take this opportunity to again express our profound gratitude to him.

Yilmaz Dziewior
Kunstverein in Hamburg

Matthias Mühling
Städtische Galerie im Lenbachhaus und Kunstbau, München

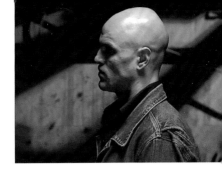

Splitter

Francis McKee

Draußen in Jütland
In den alten mörderischen Gemeinden
Fühle ich mich verloren,
Unglücklich und zu Hause.
(Seamus Heaney, »The Tollund Man«)

Es ist fast schon ein urbaner Mythos, dass Kinder in Nordirland über bis zu dreißig verschiedene Methoden verfügen, die Konfession eines Menschen herauszufinden, ohne ihn direkt danach fragen zu müssen. Ein derartiger Vorgang ist symptomatisch für das Leben in dieser Region – Menschen und ihre Umgebungen müssen überprüft, analysiert und dechiffriert werden. Parallel zu den offiziellen militärtechnischen Netzwerken hat sich hier ein volkstümliches Sicherheitssystem entwickelt, dessen treibender Impuls das Misstrauen gegenüber den Erscheinungen einer Realität ist, die es anzuzweifeln und gründlich zu hinterfragen gilt. Gleichzeitig formt und zementiert die Grundlage solcher Befragung – die Identifizierung bestimmter Namen, Schulen, Bezirke, Gesichtszüge oder Bräuche als Indikatoren stammesmäßiger Herkunft – noch die Konfliktsituation.

Dieser Weltdeutungsansatz prägt die Videoarbeiten von Willie Doherty und liefert den Ausgangspunkt für seine eigene Hinterfragung von Wahrnehmung und visuellen Medien. Das Gesehene ist schlechterdings niemals mit dem Gegebenen identisch. Es müssen stets Interpretationen vorgenommen, Widersprüche eingeräumt und Standpunkte akzeptiert werden. Die Bedeutung des Kontextes innerhalb seiner Arbeiten ist kaum zu überschätzen.

In seiner künstlerischen Praxis wurde Doherty nicht nur von einer bestimmten politischen Situation beeinflusst, sondern auch von einer sehr konkreten Landschaft, bei der sich natürliche und technische Elemente in einzigartiger Form verbinden. Der Ausbruch des Nordirland-Konfliktes im Jahre 1969 hatte zur Folge, dass diese Provinz bis in die späten 1970er-Jahre eine der am stärksten militarisierten Zonen ganz Europas wurde. Die Aufhebung normalen demokratischen Lebens erlaubte es den folgenden britischen Regierungen, das Gebiet als Testareal für neue Technologien und gleichzeitig als Experimentierfeld für die Schaffung einer Kontrollgesellschaft zu nutzen.

Diese komplexe Situation bedingte eines der ersten wirklich postmodernen Milieus, auch wenn dies in der Regel nicht erkannt wurde, weil es in einer Provinzgesellschaft verwurzelt war. Eine häufiger gewürdigte Landschaft findet sich hingegen in der berühmten Abhandlung des marxistischen Literaturkrikers Frederic Jameson über die Postmoderne, »Postmodernism, or, The Cultural Logic of Late Capitalism« (in: *New Left Review* 146, 1984; dt. »Postmoderne. Zur Logik der Kultur im Spätkapitalismus«), in welcher die desorientierende Architektur des Bona-

venture Hotel in Los Angeles analysiert wird, um zu dem Schluss zu gelangen, diese erfordere letztlich eine radikale Neubeurteilung von Wahrnehmung:

»Ich nehme mich der Vorstellung an, dass mitten unter uns im bebauten Raum eine Art Mutation existiert. Ich deute damit an, dass wir selbst, die menschlichen Subjekte, die sich zufälligerweise an diesem neuen Ort befinden, mit dieser Form der Evolution nicht Schritt gehalten haben. Es hat eine Mutation des Objekts stattgefunden, mit der bis jetzt allerdings noch keine vergleichbare Mutation des Subjekts einhergegangen ist. Wir verfügen nicht über das diesem neuen Hyperraum angemessene Wahrnehmungsinstrumentarium, weil sich unsere Wahrnehmungsgewohnheiten unter anderem in jenem älteren Raum ausgebildet haben, den ich den Raum der Moderne nenne. Die jüngere Architektur steht daher – wie viele andere zuvor genannte Produkte – für das Gebot, neue Organe auszubilden, unser Sensorium und unseren Körper auf noch unvorstellbare, vielleicht letzten Endes unerreichbare Dimensionen hin zu erweitern.«

Jamesons Bemerkungen basieren auf dem urbanen Stimulus, das Neue zu kritisieren, wobei er impliziert, dass Veränderungen des kulturellen Empfindens immer von den großstädtischen Zentren ausgehen. Die Postmoderne wird gemeinhin als popkulturelles Phänomen betrachtet, das sich im Bereich der Musik, Architektur, Mode und Literatur beobachten lässt. Und dennoch hätte man den profundesten Einfluss des von Jameson Beschriebenen womöglich leichter in der Landschaft von South Armagh, in den Straßen von Shankill in Belfast oder im Stadtteil Bogside in Derry finden können.

Die gesamten 1970er- und 80er-Jahre hindurch bestimmte eine hartnäckige Serie sektiererischer Mordanschläge und Bombenattentate die Alltagsrealität der nordirischen Bevölkerung. Auch viele andere Länder mussten, wie in der jüngeren Vergangenheit erst Vietnam, in ihrer Geschichte die Erfahrung von Partisanenkriegen machen. Doch eine sich in Irland abzeichnende Veränderung betraf die flächendeckende Präsenz elektronischer Medien, die mit der Errichtung einer umfassenden Militäraufsicht einherging. Entdeckte man an einer weit entfernten Landstraße in der Nähe einer Kleinstadt wie Newtownhamilton beispielsweise eine Leiche, so konnte die Bevölkerung den Fund am Fernseher mitverfolgen und beobachten, wie dieser mit Hilfe eines Roboters auf Sprengladungen untersucht wurde. Auch war unter Umständen zu Hause die Wucht einer Explosion daran zu spüren, dass die Fenster bebten. Die sicherste Erklärung für einen solchen Vorfall ließ sich finden, wenn man zur Begutachtung des Schadens den Fernseher einschaltete und die Analyse bezüglich möglicher Motive des Bombenlegers abwartete. Die sich allwöchentlich wiederholenden Bürgerkriegsbilder brannten sich nach und nach in die Psyche ein – die Erschießung am Straßenrand, die Ruine eines Hauses, der Militärposten, Straßensperren, der Molotowcocktail, die Kaserne.

Ein Guerillakrieg in einer Gegend mit derart kleinen Gemeinden führt umgehend zu einer weiteren, noch unheilvolleren Erscheinung. Schon bald nämlich ist die Mehrheit der Menschen direkt vom Läuten der Totenglocken betroffen, so dass sich jeder Bewohner selbst als mögliche Zielscheibe empfindet. Außerdem lebt man im ständigen Bewusstsein, dass die Gewalt nur durch Duldung seitens einer schweigenden Gemeinschaft stattfinden kann, und muss

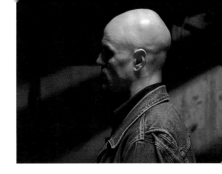

damit erkennen, dass man sich möglicherweise als Gesellschaft selbst schuldig macht oder, noch schlimmer, über ein gewalttätiges oder »böses« Potenzial verfügt.

Die durch eine solche Situation forcierte Selbstreflexion vermischt sich mit dem allgegenwärtigen Bewusstsein einer strikten Militärüberwachung. Nordirland wurde berühmt durch Landschaften mit Wachtürmen und über die Hügel verteilten Abhörstationen, die sämtliche Lebensaspekte kontrollierten. Alltägliche, profane Handlungen gewannen eine neue Bedeutung, wenn sie sich mit der Welt der Nachrichten vermischten. Alles schien kodiert zu sein – eine an sich belanglose Handlung konnte neu oder auch fehlgedeutet werden. Das Gefühl, beobachtet zu werden, war gesellschaftlich verinnerlicht worden. Unter derartigen Bedingungen entwickeln die Einheimischen einen distanzierteren zweiten Blick auf ihr Leben im Sinne einer »Performance«. Sie nehmen sich selbst so wahr, wie sie möglicherweise von anderen wahrgenommen werden, und leben nicht nur ihr Leben, sondern inszenieren es gleichsam.

Elemente dieser psychologischen Situation werden auch in verschiedenen Videos von Willie Doherty deutlich. So basieren *No Smoke Without Fire* (1994), *Tell Me What You Want* (1996) und *Sometimes I Imagine It's My Turn* (1998) auf angedeuteten Szenarien um einen Leichenfund oder eine Hinrichtungsszene. In diesen Arbeiten wird allerdings ein jeweils anderer Aspekt des Szenarios untersucht.

In *No Smoke Without Fire* (S. 68 ff.) behandelt der Künstler eine unheimliche Landschaft, wie sie häufig als Kulisse eines Mordes dient – Schutt, eine ärmliche Umgebung, die Suche nach Hinweisen oder Beweismitteln, während die Kamera über den Boden gleitet. Durch die Kreisförmigkeit der Fahrt über Brachland wird zusätzlich die Unmöglichkeit eines Entkommens betont. Dohertys Filmsprache ist gnadenlos ehrlich. Anstatt die Schwächen des Videomaterials, die fehlende Tiefe und die grellen Farben zu verbergen, erkennt er sie an und nutzt diesen Eindruck zur Spiegelung der Ärmlichkeit der Szene. Die Videoaufnahmen verfügen häufig über eine mäßige oder sogar mangelhafte Qualität – wie nicht anders zu erwarten bei nächtens selbst gedrehtem Material.

Im Gegensatz dazu spielt *Tell Me What You Want* (S. 78 ff.) eindeutig in und mit der Vergangenheit. Die beiden aus Bodenhöhe aufgenommenen Einstellungen eines Straßenrands und der nassen, von einer Natriumdampflampe erleuchteten Fahrbahn lassen auf Hinrichtungsstätten schließen, während menschliche Umrisse von latent gewalttätigen Ereignissen erzählen, in denen die Ängste Nordirlands nachklingen: »Ich hätte nie gedacht, dass mir so etwas passieren könnte. Es passiert immer jemand anderem. Jemandem, den man nicht kennt.« Die Arbeit wird auf zwei Hängemonitoren gezeigt, die den Geist des Fernsehens und der Fernsehnachrichten beschwören.

In *Sometimes I Imagine It's My Turn* (S. 92 ff.) werden Elemente aus beiden oben genannten Arbeiten kombiniert. Zwischen die den Boden abtastenden Aufnahmen aus *No Smoke Without Fire* werden kurze Schwarzweißausschnitte eingeblendet, die den Eindruck eines Nachrichtenbeitrags über einen Mordfall vermitteln, unterlegt mit dem anhaltenden Geräusch eines Hubschraubers. Diesmal allerdings liegt am Ende einer Spur aus zerbrochenen Zweigen eine

Leiche. Ihre Anwesenheit wirkt zunächst höchst prosaisch, verglichen mit früheren Arbeiten, in denen ein Verbrechen eher impliziert als direkt gezeigt wird.

Nach und nach bildet sich ein Thema heraus, das bisher nur angedeutet wurde. Doherty zieht dazu im Hinblick auf die Bildqualität zwei verschiedene Register – Schwarzweiß-Nachrichtenmaterial und qualitativ hochwertigere Farbaufnahmen, bei denen der intime Blick der Kamera über den Körper der Leiche fährt. Der Gegensatz zwischen beiden Stilen suggeriert zwei verschiedene Perspektiven: Die erste liefert einen eher objektiven Bericht, mit der zweiten hingegen verhält es sich etwas schwieriger. Die aus diesem Blickwinkel gesehenen Bilder sind zu vertraulich, als dass es sich dabei um eine polizeiliche Dokumentation über die Leiche handeln könnte. Sie könnten jedoch dem Geist eines an den Tatort zurückgekehrten Mordopfers oder aber, wie der Titel suggeriert, dem Tagtraum eines Bewohners von Nordirland entstammen, der sich vorstellt, am Ort einer Hinrichtung zu sein.

Diese eigenartige Perspektive wird erstmals in den subjektiven Kameraaufnahmen von *Tell Me What You Want* angedeutet, die nur aus dem Blickwinkel einer am Straßenrand zurückgelassenen oder auf der Straße liegenden Leiche entstanden sein können. Eine ähnliche, vom Straßenrand aus in Augenhöhe aufgenommene Einstellung wurde auch in *Sometimes I Imagine It's My Turn* zwischen die im Stil von Nachrichtenmaterial gehaltenen Aufnahmen geschnitten und vermittelt so den Eindruck, als habe sich hier jemand im Geiste die Meldung zu seiner eigenen Ermordung vorgestellt.

Doherty bringt den Zuschauer bewusst in eine unangenehme Situation und lässt ihn mit dem Versuch allein, eine mögliche Perspektive zu finden. Häufig sind die einzigen Anhaltspunkte vieldeutig und versetzen den Betrachter in die Situation eines Toten oder Mörders. Diese unklare Heimsuchung durch Opfer und Täter geht auf frühe Videoarbeiten wie *The Only Good One Is a Dead One* (1993, S. 58 ff.) zurück, in der eine körperlose Stimme sich vorstellt, sowohl ermordet zu werden als auch aus Rache selbst zu töten. Dieselben Mehrdeutigkeiten durchziehen bis heute Dohertys Werk, wobei seine Perspektive an Subtilität und Komplexität zunahm.

In *Closure* (2005, S. 142 ff.) beispielsweise verfolgt die Kamera eine Frau, die sich durch eine nicht weiter bestimmbare Sicherheitsanlage bewegt. Während das Objektiv sich auf ihr Gesicht richtet, ist eine Frauenstimme zu hören. Das Dilemma des Zuschauers besteht darin zu erkennen, welche Position er mental einnehmen muss, um die Arbeit zu verstehen. Die Kamera deutet eine distanzierte Überprüfung der Frau an, während die weibliche Stimme einen inneren Monolog spricht. Als Betrachter kann man in diesem Film nur dann »überleben«, wenn man sich einerseits in die Psyche der Frau begibt und sie gleichzeitig wie ein Bildnis studiert. Zwingt man sich jedoch, sich in die Frau hineinzuversetzen, so erlebt man die von ihr beschriebenen apokalyptischen Szenen umso eindringlicher:

»Der Riss bricht auf. / Das Glas ist zerschlagen ...«

»Die Straße steht in Flammen. / Der Stahl ist verbogen. / Der Boden schmilzt.«

Auch in Arbeiten wie *Re-Run* (2002, S. 126 ff.) oder *Drive* (2003, S. 130 ff.) liegt eine Doppelperspektive vor, die einen gefangen hält. Bei *Re-Run* gibt es nicht lediglich zwei Blickrichtungen

auf den Gehenden, vielmehr finden sich die Zuschauer gleichzeitig in der Rolle des Jägers *und* des Gejagten. Das vor allem in diesen beiden Arbeiten erzeugte Unbehagen wird noch verstärkt durch den Einsatz einer doppelten Leinwand, die sie buchstäblich in einen heiklen physischen Raum versetzt, in dem die Wahrnehmung der einen Leinwand auf Kosten der anderen Perspektive und in dem Wissen geschieht, dass an anderer Stelle eine andere Perspektive einzunehmen ist. Da der Betrachter genötigt wird, zur Wahrnehmung der zusätzlichen Dimension dieser Arbeit selbst eine physische Wendung oder Reise zu unternehmen, ist der Akt des »Zusehens« kein passiver Vorgang mehr. Stattdessen wird er zu einer Lektion in Selbsterkenntnis, während man sich vom Gejagten zum Jäger und wieder zurück bewegt.

Das Gefühl der Un-Fassbarkeit solch körperlicher Situationen lässt an Frederic Jamesons eingangs zitierte Bemerkung über den postmodernen Raum denken: »Wir verfügen nicht über das diesem neuen Hyperraum angemessene Wahrnehmungsinstrumentarium.« Jameson kommt zu dem recht oberflächlichen Schluss, die neue Erfahrung führe zu der Notwendigkeit, neue Organe auszubilden. Dies ist ein eleganter, durchaus hinreichender Science-Fiction-Ausweg, sofern sich postmoderne Dilemmata auf Hotels in Los Angeles beschränken. In der düsteren Welt eines Willie Doherty jedoch, in der sie sich in einer gefährlichen Landschaft spiegeln, erscheint es eher angemessen, über das Gebot nachzudenken, neue moralische Fähigkeiten zu kultivieren oder die Umwelt zu transformieren.

Diese Möglichkeit der Veränderung ist ein weiteres Thema, das nahezu alle Videoarbeiten Dohertys in Form von Wiederholungen und Loops durchdringt. In *Factory (Reconstruction)* (1995), *At the End of the Day* (1994) und *The Wrong Place* (1996) werden die jeweiligen Szenarien immer wieder nachgestellt, beziehungsweise wiederholt. In *Factory (Reconstruction)* (S. 72 f.) deutet sich die Möglichkeit eines Wandels in einem verfallenen Gebäude an, in dem nichts geschieht und keine Veränderungen feststellbar sind. Auch in *The Wrong Place* (S. 74 ff.) werden Kamera und Zuschauer dazu verdammt, einem endlosen, Furcht erregenden Wettlauf durch ein verlassenes Gebäude beizuwohnen.

At the End of the Day (S. 64 ff.) hingegen vermittelt im Unterschied zu zahlreichen anderen Arbeiten Dohertys das unausgesprochene Gefühl der Veränderung innerhalb einer Kreisstruktur. Während die Kamera ein Auto bis zu einem letztlich negativen Schlusspunkt verfolgt (eine Militär-Straßensperre in ländlicher Umgebung), wird diese Fahrt in Echtzeit vom Zeitpunkt der Abenddämmerung bis zur Dunkelheit wiederholt. Durch den feinen Unterschied, dass hier die Szene immer wieder aufs Neue nachgespielt wird, anstatt dieselbe Szene hintereinander zu loopen, wird darauf hingewiesen, dass die Fahrt, falls gewollt, jederzeit unterbrochen oder ihre Richtung verändert werden könnte. Die schwache Andeutung von Optimismus in Gestalt des im Titel der Installation *Factory* in Klammern gesetzten Wortes »reconstruction« (»Wiederaufbau«) suggeriert ebenfalls, dass eine Veränderung nicht ausgeschlossen ist.

Diese Welt aus Loops und Wiederholungen droht eines der zentralen Probleme der Postmoderne aufzuwerfen und die endlose Spirale aus Verweisen und kulturellen Anspielungen unendlich um sich selbst kreisen zu lassen. Begriffe wie Handlung und Fortschritt sorgen dabei

für keinerlei Erleichterung, da die postmoderne Vorliebe für Selbstreferenz die Geschichte lähmt. Doherty entgeht dieser Sackgasse jedoch vermittels kleinster Andeutungen und eines Beckettschen Sinns für Resignation, der an die berühmten Worte des irischen Dramatikers erinnert: »Ich kann nicht weitermachen. Ich werde weitermachen.« Der Künstler erkennt in seinen Arbeiten das Potenzial endloser »Zyklen der Gewalt« an, bekräftigt jedoch das Bedürfnis, ungeachtet solch düsterer Aussichten nach vorn zu blicken.

Mit dem Waffenstillstand in Nordirland gewann diese Position eine neue Dimension. Während man in der Provinz damit begann, den Kreislauf der Gewalt zu durchbrechen, ist Doherty in seinen Arbeiten den Wiederholungen und der Dunkelheit treu geblieben. *Non-Specific Threat* (2004) und *Passage* (2006) weisen nach wie vor nordirische Wesenszüge auf, insbesondere was das Aussehen der Figuren und die in jeder Situation wahrnehmbare Bedrohung betrifft. In *Non-Specific Threat* (S. 136 ff.) werden die Zuschauer zur Anerkennung ihres eigenen Gewaltpotenzials gezwungen, in *Passage* (S. 148 ff.) wiederum geht es um Konfrontation und die Fähigkeit der Bewohner von Ulster, in einer sich nähernden Person unmittelbar Freund oder Feind zu erkennen. Vielleicht aber lässt sich diese Arbeit nun auch wesentlich allgemeiner deuten. Denn ironischerweise könnte *Passage* ebenso gut von einer potenziell schwulen Begegnung in einem Park handeln (vgl. S. 36), und auch wenn *Non-Specific Threat* von der Reaktion des Künstlers auf einen Film über Nord-Belfast ausgeht, so hebt die Kulisse des Films, eine Lagerhalle, einen derart engen Zusammenhang auf.

Dohertys Arbeitsaufenthalt in Berlin 2000 war unter anderem deshalb aufschlussreich, weil er die Reaktion des Künstlers auf andere Kulturen und Landschaften offenbarte und insofern einen Maßstab für seine »irischen« Arbeiten lieferte. In vielerlei Hinsicht lässt sich die Kritik an einer in Ulster vorherrschenden Festungsarchitektur und brutalisierten Umgebung, die sich in all seinen Videos findet, auf eine allgemeinere Lesart zeitgenössischer Kultur ausdehnen. So belegt Dohertys aus in Berlin aufgenommenen Schwarzweißfotos bestehender Werkkomplex *Extracts From a File / Aktenauszug,* wie jene militarisierte, streng überwachte Welt des Bürgerkriegs über Irland und den Kalten Krieg hinaus zur gesellschaftlichen Norm wurde.

In gewisser Weise erklärt sich aus Dohertys Art, sich Berlin zu nähern, auch die breite Popularität, die sein Werk außerhalb Nordirlands genießt. Es gibt in seinen Arbeiten einen Bereich äußerst spezifischer Bezüge, die bei allen, die den Nordirland-Konflikt in der Provinz miterlebt haben, auf ein Echo stoßen. Allein die Titel operieren auf einer vertrauten, ja fast klischeehaften Ebene und basieren auf der örtlichen Sprache der Einheimischen. Eine Arbeit wie *Blackspot* (1997, S. 88 ff.) beispielsweise ist für einen Bürger Nordirlands natürlich unmittelbar verständlich. Überraschend ist jedoch die Tatsache, dass sie trotz solch unauflösbarer Codes auch jenseits von Dohertys Heimat verstanden wird. Dieser Erfolg liegt gewissermaßen darin begründet, dass die postmoderne Erfahrung von Überwachung, Sicherheit und Kontrolle in die ganze Welt exportiert wurde. Was einst Resultat neuer militärischer Techniken war, ist zum weltweiten Standardmodell von Stadtplanung geworden.

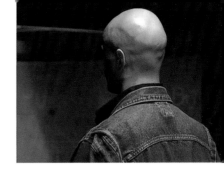

Darüber hinaus lassen sich Dohertys Videoarbeiten auch innerhalb eines umfassenderen filmischen Kontexts betrachten, das heißt nicht nur als Teil der zeitgenössischen Kunst, sondern innerhalb eines ganzen Spektrums von Massenmedien, das von Fernseh-Kriegsberichten bis hin zu Horrorfilmen reicht. In seinen Arbeiten wird oft ein Gefühl des Traumatischen behandelt, durch das eine Reaktion hervorgerufen wird, die weit über die Bevölkerung Nordirlands hinausgeht.

Es mag zunächst als ein von seinen eigenen Arbeiten weit entferntes Genre erscheinen, doch auch Horrorfilme wie *Night of the Living Dead / Die Nacht der lebenden Toten* (1968), *The Last House on the Left / Das letzte Haus links* (1972) und die Pseudodokumentation *(The) Blair Witch Project* (1999) gehen sämtlich von einer Anerkennung jüngster Kriege, dokumentarischer Techniken und wahlloser, gnadenloser Gewalt aus. Dohertys Arbeiten berühren einige dieser Aspekte auf weniger spektakuläre Weise, doch mit einem ähnlichen Interesse am Unbehagen des Publikums. Der Off-Text aus der erwähnten Installation *Closure* (2005, S. 142 ff.) beispielsweise liest sich auf dem Papier wie Lyrik, könnte jedoch auch die Grundlage eines Drehbuchs zu einem alptraumhaften Horrorfilm bilden:

»Das Dach zerfällt.
Von der Decke tropft es.
Der Fußboden steht unter Wasser.

Meine Intuition ist tödlich.
Mein Urteil ist maßgeblich.

Die Tür ist undicht.
Die Wand ist feucht.

Mein Glaube ist ungetrübt.
Meine Treue ist beständig.

Der Rand ist unscharf.
Die Grenze ist sichtbar.«

In ähnlicher Weise werden auch in *The Wrong Place* (1996, S. 74 ff.) klassische Spukhaus-Szenarien heraufbeschworen, welche die Handlung auf den zentralen Grusel des Unbekannten und die unvermeidlich folgende Verfolgungsjagd reduzieren.

Doherty füllt diese Videos dennoch mit einer raffinierten plastischen Sensibilität aus, die es ihm erlaubt, derartigen Bildern eine geradezu körperliche Wirkung auf die Betrachter zu verleihen, so dass diese sich vom passiven Publikum in Beteiligte eines verinnerlichten Dramas verwandeln. Die Arbeit vor der Kulisse nachweislicher Brutalitäten und Auseinandersetzungen führt

auch zu einer Steigerung des Schreckens in seinen Werken, der diese in eine gefährliche Nähe zu realen Tragödien rückt. Gleichzeitig gewährt ihm der Kunstbetrieb eine gewisse Freiheit von filmischen Orthodoxien, die ihm ein eindringlicheres Spiel mit Elementen wie Wiederholung und Maßstab oder der Innerlichkeit einer Off-Stimme ermöglicht. In diesem Umfeld lassen sich die paradoxen Qualitäten von Bewegung und Handlung, Trauma und Lähmung oder endlosem Gefangensein nutzen, die dem bewegten Bild anhaften.

Dohertys Werk ist Resultat seines Verständnisses der Beziehung zwischen zeitgenössischer Architektur, angewandter Sozialwissenschaft, kulturellen Ängsten und dem Medium Video. Das existenzielle Gefühl für die menschliche Veranlagung zu Gut und Böse ist eng verwandt mit dem tiefen Wissen davon, wie das Denken funktioniert, sich selbst Nahrung liefert und dabei endlos Bilder aufsaugt und generiert. Die klaustrophobischen Wiederholungen und Neufassungen von bewussten und unbewussten Fantasien beleben jene dunklen Tagträume, die für diese Videos so charakteristisch sind.

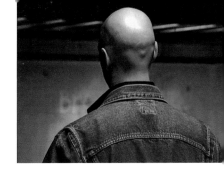

Smithereens
Francis McKee

Out here in Jutland
In the old man-killing parishes
I will feel lost,
Unhappy and at home.
—Seamus Heaney, *The Tollund Man*

It is almost an urban myth that children in Northern Ireland have up to thirty ways to identify someone's religion before having to ask the question directly. The process is symptomatic of life in that region—people, like their surroundings, are to be scanned, analyzed, and deciphered. It is a folk-based security system that has developed parallel to the official networks of military technology. The impulse driving the system is a belief that the appearance of reality cannot be trusted and must be interrogated thoroughly. At the same time, the basis of interrogation—identifying certain names, schools, districts, facial characteristics, or fashions as signs of tribal affiliation—perpetuates and shapes a situation of conflict.

This approach to reading the world informs the video work of Willie Doherty and provides a starting point for his own interrogation of perception and visual media. What we see is never simply what we get. There are always interpretations to be made, contradictions to be acknowledged, and positions to be agreed. It is hard to overestimate the importance of context in his work.

Doherty's practice was shaped not only by a particular political situation, but a physical landscape, combining both natural and technological elements in a unique configuration. The eruption of the "troubles" in Northern Ireland, in 1969, meant that by the late 1970s the province was one of the most highly militarized zones in Europe. The suspension of normal democratic life enabled successive British governments to use the region as a testing ground for new technologies, an experiment in creating a contemporary controlled society.

This intense situation created one of the first truly postmodern environments, one that has often been unacknowledged because it was rooted in a provincial society. The landscape that is more often recognized is to be found in Frederic Jameson's celebrated treatise on postmodernism, "The Cultural Logic of Late Capitalism," in which he analyzed the disorienting architecture of the Bonaventure Hotel, in Los Angeles. He argues that this architecture calls for a radical reassessment of perception:

I am proposing the notion that we are here in the presence of something like a mutation in built space itself. My implication is that we ourselves, the human subjects who happen into this new space, have not kept pace with that evolution; there has been a mutation in the object unaccompanied as yet by any equivalent mutation in the subject.

We do not yet possess the perceptual equipment to match this new hyperspace, as I will call it, in part because our perceptual habits were formed in that older kind of space I have called the space of high modernism. The newer architecture therefore—like many of the other cultural products I have evoked in the preceding remarks—stands as something like an imperative to grow new organs, to expand our sensorium and our body to some new, yet unimaginable, perhaps ultimately impossible, dimensions.

Jameson's comments are based on an urban impulse to critique the new, implying that changes in cultural sensibilities are always driven from metropolitan centres. Postmodernism has generally been considered as a pop-cultural phenomenon—to be found in music, architecture, fashion, and literature. And yet, the most profound influence of what Jameson describes could have been more easily found in the landscape of South Armagh, the streets of the Shankill in Belfast, or the Bogside in Derry.

Throughout the 1970s and '80s, a persistent series of sectarian killings and bombing campaigns became routine reality for the population of Northern Ireland. Many countries had experienced guerrilla war before, most recently Vietnam. What changed in Ireland was the blanket presence of broadcast media allied to the installation of sweeping military surveillance. When a body was discovered in a remote country lane near a small town like Newtownhamilton, for instance, the population would watch the discovery on television and could follow developments as the body was examined by a robot for booby-trap bombs. Similarly, the impact of an explosion could be felt at home, where the windows might shake, and then it could be more safely explained by turning on the television to see the damage and hear analysis of the bomber's possible motives. Repeated on a weekly basis, the images of that conflict became ingrained in the psyche—the roadside execution, the ruins of a building, the military checkpoint, barricades, the petrol bomb, the fortified barracks.

A guerrilla war in a province of such small communities quickly breeds another, more sinister, aspect. Very soon the death toll touches most of people—everyone senses he or she may be a target. Equally, there is always an awareness that the violence can only occur with the support of silent, permissive communities. Everyone then realizes they may be guilty by association or worse, may themselves have a capacity for violence or evil.

The self-reflection instigated by such a situation is compounded by the awareness of high-level military surveillance. Northern Ireland became famous for its landscape of watch-towers and listening stations, scattered across the hills, monitoring every aspect of daily life. Routine or mundane actions assumed a new importance as they were absorbed into the world of intelligence. Everything seemed coded—an insignificant task could be reinterpreted or misinterpreted. The sense of being watched was internalized in the communities and, in these conditions, inhabitants develop a more distant, second view of their life as a "performance," seeing themselves as they imagine they may be seen by others, enacting a life as much engaging in it.

Elements of this psychology are evident in certain video works by Willie Doherty. *No Smoke Without Fire* (1994), *Tell Me What You Want* (1996), and *Sometimes I Imagine It's My Turn*

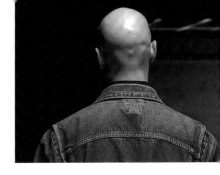

(1998), all build on implied scenarios of a dumped body, an execution scene. Each, though, explores a different aspect of the scenario. *No Smoke Without Fire* dwells on the abject landscape that is often the backdrop for a murder—the rubbish, the poor land, the search for clues or evidence as the camera sweeps the ground. The circularity of the journey around a wasteland also underlines the impossibility of escape. Doherty's filming style is brutally forthright. Rather than disguise the weaknesses of video—its lack of depth and its garish color palette—he acknowledges them and uses their impoverishment to mirror that of the scene. The quality of the video shots is often poor or average—what we might expect if we filmed it ourselves at night.

In contrast, *Tell Me What You Want,* effectively plays in the past tense. Two ground level shots of the side of a road and a wet, sodium lighted street suggest execution spots, while silhouetted heads recount potentially violent events, echoing the anxieties of Northern Ireland: "I never thought it would happen to me. It's always someone else. Someone you don't know." The piece is shown on two suspended monitors evoking the ghost of television and the news.

Sometimes I Imagine It's My Turn combines elements of both these earlier works. The eyes-to-the-ground style of *No Smoke Without Fire* is intercut with brief black-and-white clips that suggest news footage of a murder scene, underscored by the persistent sounds of a helicopter. This time, though, there is a body at the end of a trail of broken branches. Its presence at first seems overly literal when considered in the light of the earlier works where a crime is implied rather than shown. However, as the video unfolds it develops an issue that was only hinted at in the previous pieces. Doherty uses two registers of video quality—black-and-white news footage and richer, color shots that travel intimately over the body. The contrast between the two registers suggests two differing points of view. The first suggests a more objective report; the second is more problematic. It is too intimate to be police documentation of the dead body, but it could be the spirit of the victim revisiting the scene or as the title suggests, the daydream of anyone in Northern Ireland imagining themselves into an execution scenario.

This strange perspective is first suggested in the point of view shots from *Tell Me What You Want,* which could only be seen from the eyes of a dumped body at the roadside or lying in a street. A similar eye-level roadside shot is even included in *Sometimes I Imagine It's My Turn* amid the news-style clips, suggesting the fabrication of the news of one's own murder in the imagination.

Doherty deliberately places the viewer in an uncomfortable position, or goes further and leaves the viewer struggling to find a point of view to inhabit. Often the only points left to settle on are ambiguous and leave the viewer in the shoes of a dead man or in the shoes of the killer. This ambiguous haunting of the victim and the perpetrator goes back to Doherty's very early video work, such as *The Only Good One Is a Dead One* (1993), where a disembodied voice both imagines being killed and performing a revenge killing. The same ambiguities have continued through to the present day but the point of view has become increasingly subtle and complex.

In *Closure* (2005), for example, a camera tracks alongside a woman walking inside a nondescript security installation. As the lens closes in on her face, the viewer hears a woman's

voice. The dilemma for viewers is in knowing where to position themselves mentally to receive the piece. The camera suggests scrutiny and distance from the woman, but the voiceover implies an interior monologue. We can only survive as viewers within the piece by accepting that we are both inhabiting the woman's psyche and simultaneously studying her as if a portrait. Forced into her mind, however, we experience more closely the apocalyptic scenes she is describing:

The crack is splitting. / The glass is shattered …

The street is ablaze. / The steel is twisted. / The surface is melting.

Equally, in works such as *Re-Run* (2002) and *Drive* (2003), there is a double viewpoint in which the viewer is entrapped. With *Re-Run,* this not only gives two perspectives on the runner but places the audience in the role of the hunted and the hunter.

The discomfort engendered by these two pieces in particular is intensified by Doherty's use of double screens, literally placing the viewer in an awkward physical space where the perception of any one screen is at the expense of the other viewpoint, and in the knowledge that there is another viewpoint elsewhere to experience. By compelling the viewer to physically make the turn, or journey to experience the other dimension of the piece, "viewing" is no longer passive. Instead, it becomes a lesson in self-knowledge as we choose to move from hunted to hunter and back again. Our sense of inadequacy in these physical situations echoes Frederic Jameson's comment on postmodern space in which he states: "We do not yet possess the perceptual equipment to match this new hyperspace." Jameson comes to the fairly glib conclusion that the new experience leads to "an imperative to grow new organs." It is a neat sci-fi escape route that suffices if postmodern dilemmas are limited to hotels in Los Angeles. In Doherty's darker world, mirroring dilemmas in a dangerous landscape, it seems more appropriate to consider an imperative to cultivate new moral faculties or transform the surrounding environment.

This possibility for change is another issue that permeates almost all of Doherty's video work through his use of repetition and loops. In *Factory (Reconstruction)* (1995), *At the End of the Day* (1994), and *The Wrong Place* (1996), scenarios play out and repeat endlessly. *Factory (Reconstruction)* implies the possibility of change in a ruined building where nothing gets done and no change is evident. Similarly, *The Wrong Place* condemns the viewer and the camera to a terrifying and never-ending race through an abandoned building. *At the End of the Day*, unlike many of Doherty's works, offers an implicit sense of change within its circular structure. While the camera follows a car to an ultimately negative conclusion (an army barricade across a country road), the journey is repeated in real time from twilight to darkness. That slight difference, playing out the scene repeatedly rather than looping the same footage, hints that the journey could be broken or change direction if the desire was there. The faint hint of optimism in the bracketed word "reconstruction" in the title likewise suggests change is not impossible.

This world of loops and repetitions threatens to raise one of the central problems of postmodernism where an endless spiral of reference and cultural allusion can twist in on itself endlessly. Concepts such as action and progress become impossible to facilitate, as postmod-

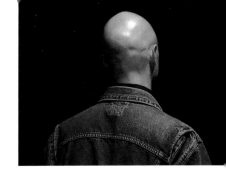

ernist self-reference paralyzes history. Doherty evades this cul-de-sac through the slightest of hints and through a Beckettian sense of resignation, recalling Samuel Beckett's lines, "I can't go on. I'll go on." Doherty's work acknowledges the potential for endless "cycles of violence," but affirms a need to move forward despite this bleak prospect. With the ceasefire in Northern Ireland, this position has acquired another dimension. While the province has begun to break its cycle of conflict, Doherty's work has not abandoned its repetitions or darkness. *Non-Specific Threat* (2004) and *Passage* (2006) still have recognizable Northern Irish traits, particularly in the look of the characters and the implied threat in each situation. *Non-Specific Threat* draws viewers into an acknowledgement of their own capacity for violence while *Passage* hints at confrontation and the ability of Ulster residents to read an approaching figure as friend or foe. Perhaps, though, the pieces can also be read more generally now. Ironically, *Passage* could as easily suggest a potential gay sexual encounter in a park, and though *Non-Specific Threat* has its roots in the artist's reaction to a film about North Belfast, the setting of the video in a warehouse removes it from such close ties.

Doherty's residency in Berlin, in 2000, was also intriguing as it revealed how he responds to other cultures and landscapes, and provided a measure of his Irish work. In many ways, the critique of the fortified architecture and the brutalized environment of Ulster, which runs through his videos, is extended into a broader reading of contemporary culture. His body of photographs from Berlin, *Extracts From a File,* demonstrate how that militarized, intensely surveyed world of conflict became the norm for society beyond Ireland and beyond the cold war.

In a sense, too, his approach to Berlin explains the wider popularity of all his work beyond Northern Ireland. There is a range of very specific references in Willie Doherty's work that resonates for those who have lived through the "troubles" in that province. The titles alone operate on a level of familiarity, and even cliché based on local speech. A work such as *Blackspot* (1997) is instantly recognizable in many intimate ways to a Northern Irish local. But the surprise in Doherty's work is that, despite such unbreakable codes, it is readable beyond his home territory. The answer to this success lies, in some respects, in the way in which the postmodern experience of surveillance, security, and control have been exported across the world. What once was a product of new military techniques is now a standard model for urban planning across the globe.

Moreover, Doherty's video work can be viewed within a wider context of the moving image, not just in contemporary art, but in a spectrum of mainstream media, ranging from war-strewn broadcast news to horror films. There is a sense of trauma that is often commented on in his work and this evokes a response far beyond that of a Northern Irish population. It may seem to be a distant genre, but horror films such as *Night of the Living Dead* (1968), *The Last House on the Left* (1972), and *The Blair Witch Project* (1999), all work out from an acknowledgement of recent wars, documentary styles, and random, unflinching violence. Doherty's video work touches on several of these aspects in a less spectacular fashion, but with a similar interest in discomforting an audience. The soundtrack of *Closure,* for instance, could read as poetry on the page, but could also form the basis of a nightmarish horror script:

The roof is decomposing.
The ceiling is dripping.
The floor is submerged.

My intuition is fatal.
My judgement is decisive.

The door is permeable.
The wall is penetrated.

My faith is undimmed.
My loyalty is unwavering.

The edge is blurred.
The boundary is invisible.

Likewise, *The Wrong Place* evokes classic haunted house scenarios, reducing the plot to the essential horror of the unknown and the chase that inevitably follows.

What Doherty brings to these videos, though, is a highly sophisticated sculptural sensibility which allows him to follow through such images with an accompanying physical impact on viewers that transforms them from passive audience to implicated participants in an internalized drama. Working against the backdrop of verifiable brutality and conflict also sharpens the horror in his work, drawing it dangerously close to real tragedy. At the same time, the art world offers a freedom from cinematic orthodoxies that permits him to play more forcefully with elements such as repetition and scale, or the interiority of a voiceover. In that environment, Doherty can exploit the paradoxical qualities of movement and action, trauma and paralysis, or endless entrapment that are inherent in the moving image.

It is Doherty's understanding of the relationship between contemporary architecture, social engineering, cultural anxieties, and the medium of video that animates his growing body of work. An existential sense of the human capacity for good and evil is allied to a close working knowledge of how the imagination operates and feeds off itself, absorbing and generating endless images. The claustrophobic repetitions and reworkings of fantasies, both conscious and unconscious, stimulate the dark daydreams that characterize these videos.

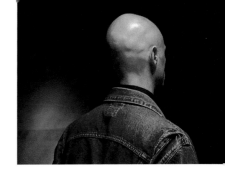

At the End of the Day It's a New Beginning
Matthias Mühling

Seit die Videobilder laufen lernten, wurden sie eingesetzt, um zu überwachen: in Gefängnissen zur Kontrolle der Insassen, in Kaufhäusern auf der Suche nach Ladendieben, aber auch im öffentlichen Raum im Auftrag reiner Prävention davor, was dort vielleicht passieren könnte. In Städten auf Straßen und Plätzen oder in der U-Bahn wird jedes Objekt, das sich bewegt, vom Auge einer Kamera verfolgt. Es wird überwacht, aufgezeichnet und kontrolliert. Wer unterwegs ist, scheint sich bereits dadurch verdächtig zu machen.

Willie Dohertys Videoinstallation *Blackspot* von 1997 (S. 88 ff.) zeigt über die Dauer einer halben Stunde den kleinen Ausschnitt einer Stadt mit Straßen, Häusern, Fahrzeugen und Menschen, die sich darin bewegen. Autos fahren vorbei, Personen verlassen ihre Häuser, gehen eine Straße entlang oder kommen heim. Langsam wird es dunkel, die Nacht bricht herein. Die Szenerie wird zusehends unübersichtlicher, und mit dem Verschwinden des Lichts verlieren sich die Details. Dann beginnt alles von neuem – der Loop der Videoinstallation wiederholt den Prozess in unendlicher Folge. Was friedlich aussieht, ist laut Titel jedoch ein »Blackspot«, eine »Gefahrenstelle«. Und wo Gefahr lauert, wird beobachtet.

Die Kamera des Videos ist auf dem historischen Stadtwall von Derry in Nordirland installiert. Ihre Bilder zeigen uns einen Ausschnitt aus der Bogside, jenem Ort, an dem die »Troubles«, wie die Schlacht der Bogside 1969 euphemistisch tituliert wird, oder der »Bloody Sunday« von 1972 stattgefunden haben. Wo der Künstler sein Objektiv positioniert hat, stehen heute noch die Überwachungskameras der britischen Armee. Wie von einem Feldherrenhügel wird versucht, anhand technischer Bilder Übersicht über das potenzielle Schlachtfeld zu gewinnen. Der Apparat demonstriert Macht durch seine reine Anwesenheit. Die Kamera ist damit kein unschuldiges Gerät, sie wird seit ihrer Erfindung, seit der chronofotografischen Flinte, mit einem Gewehr assoziiert. Und immer noch dient sie dort, wo sie im Sinne militärischer Aufklärung zum Einsatz kommt, als Waffe. Zwar wirkt sie nicht tödlich, doch sie kann verletzen. Angeblich beobachtet sie objektiv und unbestechlich, doch belegt sie dieses Vorgehen durch den Akt an sich schon mit Verdacht.

Denn immer sind es Menschen, die andere mit einer Absicht beobachten, die seit jeher ideologisch infiltriert ist. Immer sind es Menschen, die interpretieren, was das Kameraauge aufzeichnet. Bereits wer eine bestimmte Tür öffnet und eintritt, kann Argwohn erregen. Die bloße Anwesenheit der Kamera kontaminiert das Alltägliche mit vermeintlich ungesetzlicher Überschreitung. Wer innerhalb ihres Fokus auftaucht, ist damit schon inkriminiert. Es gibt kein Entkommen aus dieser Konstellation von Kamera und Objekt. Das allgegenwärtige Argument, derjenige, der unschuldig sei, habe nichts zu verbergen, ist hochgradig ideologisch verfärbt. Denn auch wer unschuldig ist, möchte oft etwas verbergen: zum Beispiel sein Privatleben.

Wie *Blackspot* beschäftigen sich viele Videoarbeiten Dohertys mit der Allgegenwart politisch instrumentalisierter Bilder. Die seinen hingegen zeigen uns, wie wenig wir über die Dinge

tatsächlich wissen, die wir täglich in den Medien beobachten. Er demonstriert, wie damit Evidenzen produziert werden, die nicht wirklich Evidenz besitzen. Es handelt sich besonders um jene Bilder, die scheinbar absichtslos im Schafspelz der Neutralität daher kommen und gerade deshalb so gefährlich sind, weil sie ihre politische Absicht zu verbergen wissen. Je stärker ihnen das gelingt, desto tiefer vermag ihre Manipulation zu wirken. Seit es Bilder gibt, waren die von Herrschern – seien es Pharaonen, Cäsaren oder französische Könige – Instrumente politischer Propaganda, doch mit den technischen Bildern und dem Aufkommen der Massenmedien haben sich ihre Möglichkeiten noch vervielfacht. So kann ein suggestiver Titel unter der Abbildung eines menschlichen Gesichts in einer Tageszeitung die entsprechende Person wahlweise in einen Helden oder ein Monster verwandeln.

Same Difference von 1990 (S. 44 ff.) zeigt auf zwei identischen Dias ein aus den Fernsehnachrichten abfotografiertes Frauengesicht. Über die Bilder dieser namenlosen Person werden Wortreihen projiziert. Die erste bezeichnet sie als »MURDERER«, die zweite als »VOLUNTEER«. In der weiteren Abfolge werden den Begriffen »MÖRDERIN« oder »FREIWILLIGE« unterschiedliche Adjektive zugeordnet (vgl. S. 46). Auf der einen Seite wird das Gesicht zum Beispiel als »BARBARISCHE MÖRDERIN«, auf der anderen als »IDEALISTISCHE FREIWILLIGE« deklariert.

Die aus den Massenmedien vertraute wechselseitige Kommentierung von Bild und Titulierung wird somit als Prinzip beschrieben, in dem die semantische Kraft der Schrift zum Tragen kommt. Diese hat den Willen, sich alles Gesehene untertan zu machen. Was auch immer das Bild eines Gesichts in uns auszulösen in der Lage ist, es wird durch die wenigen Buchstaben dominiert, die auf ihm erscheinen: Wer das Wort Mörderin liest, will auch eine solche sehen. Wer das Wort Freiwillige liest, wird genau das zu erkennen glauben. Permanente Umdeutung und wechselnde Adjektive allerdings führen die Kommentierung ad absurdum. Ein Gesicht ist eben kein offenes Buch, in dem wir, wie die Physiognomiker einst glaubten, bestimmte Merkmale wie Vokabeln lesen können. Vielmehr kommt es immer auf die Perspektive des Betrachters an, die darüber entscheidet, was er sehen möchte. Wer zum Freiwilligen oder Mörder wird, ist manchmal kein Umstand, über den juristisch entschieden werden könnte – ausschlaggebend ist stattdessen die politische Ausrichtung des Betrachters, die das eine oder eben genau das andere Attribut erkennen wird. Willie Doherty deutet somit genau auf diese andere Seite des politischen Einsatzes der Bilder und konzentriert sich auf die Funktionsweisen medialer Propaganda.

Die Folie, die Dohertys Arbeiten hinterlegt ist, bildet der Nordirlandkonflikt. Es ist seine eigene Lebenswelt, mit der er aufgewachsen ist und die er über Jahrzehnte kennt. Obwohl seine Bildwelt also spezifisch politische und geografische Bezüge herstellt und die leicht akzentuierte Sprechweise das Irische häufig anklingen lässt, weisen seine Videoarbeiten weit über diese konkreten tagespolitischen Bezüge hinaus. Es ist ihre herausragende Qualität, dass sie das Potenzial besitzen, Themen wie die gesellschaftlichen Mechanismen von In- und Exklusion sowie ethnische, koloniale und religiöse Konflikte in allgemeingültiger Weise differenziert zu behandeln. Gleichzeitig werden auf ästhetischer Ebene filmische Strategien im Spannungsfeld

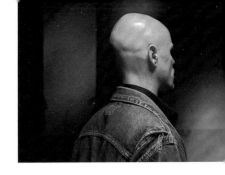

von Authentizität und Fiktion entwickelt, die Zitate aus so differenten Genres wie dem Action- oder Dokumentarfilm enthalten.

Die filmische Argumentation unterliegt einer Doppelstrategie, die sowohl ästhetisch als auch inhaltlich Themen in einer Komplexität analysiert, die universelle Gültigkeit besitzt und auf nahezu alle Konflikte verfeindeter Gruppen bezogen werden könnte, welche sich als Vermächtnis kolonialer Geschichte überall in der Welt ergaben. All diesen Konflikten ist gemeinsam, dass sie koloniale oder geopolitische Interessen unter dem Deckmantel religiöser Irrationalität verschleiern. Die Argumente der einen oder anderen Seite pflegt das feindliche Gegenüber durch vermeintlich religiösen Fanatismus zu entmenschlichen. Aus der Entfernung betrachtet, werden die Zusammenhänge immer konfuser, da sie nur via Berichterstattung, also stets aus zweiter Hand, rezipiert werden.

»Was wir über unsere Gesellschaft, ja über die Welt, in der wir leben, wissen, wissen wir durch die Massenmedien«, hatte schon Niklas Luhmann 1996 in seiner Publikation *Realität der Massenmedien* festgestellt.[1] Es scheint die Geschichte nicht zu geben, nur Bilder und Nachrichten, die Diskurse über sie. Dass hier Komplexes reduziert wird, ist selbstverständlich, denn das jeweilige Thema wird durch die Medien nicht nur vereinfacht, um es verständlicher darzustellen, sondern zugleich in »News« transformiert, die das Interesse der Leser oder Fernsehzuschauer befriedigen sollen. Aus Argumenten werden solche für das Kameraauge. So ist unser Bild des Nordirlandkonflikts, oder, um ein anderes Beispiel zu wählen: des Libanonkriegs 2006, ausschließlich durch Nachrichtenbilder geprägt. Kaum einer ist unmittelbar beteiligt, und in den Nachrichten zirkulieren zahlreiche Klischees, genauso wie sie in der Kunst vorkommen. Dohertys Arbeiten, seine Fotografien, seine Filme, sind somit immer zugleich Analyse medialer Aufbereitung von Realität in den Massenmedien. In einem zweiten Schritt offenbaren sie, wie stark unsere Interpretation von Bildern von medial geprägten Vorurteilen dominiert werden.

Die Arbeit *Passage* von 2006 (S. 148 ff.) zeigt, wie zwei Männer aus entgegengesetzter Richtung aufeinander zu laufen. Die Handlung findet in einem nicht näher definierten Niemandsland statt, im Dunkel der Nacht, nahe einer viel befahrenen Straße, deren Geräuschpegel im Hintergrund zu hören ist. Durch das Prinzip von Gegenschnitten erhält die Annäherung der Personen vordergründige Dramatik: Der Zuschauer erwartet eine Klimax in der bevorstehenden Begegnung, doch diese verläuft ansatzweise undramatisch – erst jetzt scheinen die Männer einander zu bemerken. Der erwartete Höhenpunkt bleibt aus, nur im Vorübergehen sieht jeder dem anderen über die Schulter nach. Es folgen Variationen dieser ersten Szene – das undramatische Drama der Begegnung wiederholt sich. Der Suspense entsteht allein durch die Montage. Das Filmische der Narration, nicht die narrativen Fakten bauen die Spannung auf.

Ein Kritiker schrieb in der Zeitschrift *Artforum*, diese Männer schienen Böses im Sinn zu haben.[2] Doch es verhält sich anders: Nicht die gefilmten Männer haben etwas im Sinn, sondern der Betrachter unterstellt ihnen, etwas im Sinn zu haben. Männer, die des Nachts allein eine verlassene Straße entlang laufen, müssen sich die Unterstellung gefallen lassen, etwas Böses zu beabsichtigen. Die Vorstellung, sie wären auf dem Weg zu ihrer Großmutter, um ihr etwas vorzu-

lesen, erscheint abwegig. Doch das Fatale ist nicht die Fehlinterpretationen von Bildern, sondern die Tatsache, dass politische wie mediale Propaganda bis in unseren Alltag wirkt. Wir sind kontaminiert von Vorurteilen. Andere Personen werden in bestimmten Situationen weniger als Mitmenschen denn als latente Bedrohung empfunden. Wie die Protagonisten des Films gefangen sind im argwöhnischen Beobachten, sind wir darin gefangen, den Film argwöhnisch zu betrachten. Was wir erwarten, ist bestimmt durch mediale Erlebnisse aus zweiter Hand und nicht mehr durch reale Erfahrung.

Das gleiche Thema kulminiert in Dohertys Arbeit *Many Have Eyes but Cannot See* von 2001 (S. 114 f.), der zweiminütigen Videoinstallation zweier Nahaufnahmen vom linken und rechten Auge des Künstlers, die sich, zu unterschiedlichen Zeiten aufgenommen, asynchron bewegen. Sie versuchen, Dinge oder Handlungen zu fokussieren, die sich verborgen für den Betrachter in einem imaginären Außerhalb des Bilds abspielen. Der Titel bezieht sich auf ein Wandbild in der Bogside von Derry, auf dem die Medien als Figuren mit verbundenen Augen dargestellt sind – als Anspielung auf ihre Strategie, die von den Briten in Irland verübten Ungerechtigkeiten nicht sehen zu können / zu wollen. Gleichzeitig fungiert *Many Have Eyes but Cannot See* als eine Art Selbstporträt, welches die Darstellung des Künstlers, reduziert auf seine beiden Augen, für die menschliche Erscheinung an sich nimmt, denn im Antlitz und besonders in den Augen scheinen sich Gefühle und Charaktereigenschaften zu verdichten. Sie gelten traditionell als »Spiegel der Seele«; was sie beobachten, wie sie es interpretieren, wie sie das Beobachtete im psychischen Apparat verarbeiten, bleibt der Imagination des Betrachters überlassen. Das nicht Gezeigte ist nicht darstellbar und deshalb über den Ausschnitt des Gesichts verborgen.

Während uns bei *Same Difference*, *Passage* oder *Many Have Eyes but Cannot See* die Gesichter der Protagonisten vielleicht eine Ahnung, doch keinesfalls Aufschluss über ihre Gedanken geben, spielt in anderen Arbeiten des Künstlers der Kontrast zwischen Physiognomie und Innerlichkeit eine herausragende Rolle. Zum Beispiel wird bei *Non-Specific Threat* von 2004 oder *Closure* von 2005 (S. 142 ff.) das Bild eines Menschen durch eine innere Stimme aus dem Off konterkariert. *Closure* (engl. »Stilllegung«, »Sperrung«) etwa zeigt eine schwarz gekleidete Frau, die innerhalb einer Absperrung aus metallenen Zäunen ihre Kreise zieht. Die Kamera folgt dabei mittels Parallelfahrt in Amerikanischer Einstellung (dem Bildausschnitt, der die menschliche Figur ab etwa der Hüfte wiedergibt) ihrer schreitenden Bewegung, während ab und zu rhythmisch in die Großaufnahme ihres Gesichts geschnitten wird (Abb. S. 145, 147). Eine Stimme aus dem Off spricht abwechselnd auf die Protagonistin bezogen von deren Zielgerichtetheit (»My purpose is clear«, »My endurance is constant« …) oder von der Zerstörung unbestimmter Gegenstände, die vage mit Innenräumen assoziiert sind (»The crack is splitting«, »The glass is shattered« …). Die poetische Wirkung dieser Stimme überträgt sich auf den Rhythmus der Bilder; gleichzeitig verbreitet sich eine unbestimmte Stimmung, deren psychische Dramatik auf den Betrachter übergeht.

Non-Specific Threat (S. 136 ff.) wiederum beinhaltet eine andauernde Kamerafahrt um einen jungen Mann herum, der allein in einer verlassenen Lagerhalle steht. Während sich die

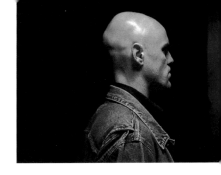

Kamera bewegt, beobachten wir den Abgefilmten und vernehmen eine Stimme aus dem Off, die in wechselnden Perspektiven von der bereits im Titel angedeuteten »unspezifischen Bedrohung« spricht (»I am the reflection of all your fears«, »Your death is my salvation«) oder einen utopischen Zustand verheißt (»I will make your dreams come true«). Durch die enorme Expressivität der eigentlich kaum wahrnehmbaren Mimik des Protagonisten und deren Kommentierung durch die suggestive Kraft der inneren Stimmen scheinen Innen und Außen, Physisches und Psychisches zu verschmelzen. Es entsteht eine wechselseitige Projektion von Latenz und Ausbruch, Gewalt und Sexualität, die, vom Körper nur angedeutet, durch die gesprochenen Worte Form gewinnt. Zukunft erscheint hier als etwas, was sich drohend entfalten wird. So spricht die Stimme vom Verschwinden der Dinge und von einem Mangel, der einmal herrschen wird: »There will be no oil« oder »There will be no music.« Die kausalen Zusammenhänge bleiben den Projektionen der Betrachter überlassen. Auf brillante Weise wird in der Kombination aus Sprache und Bild die Beziehung zwischen Realität und Fiktion, zwischen Subjektivität des Dargestellten und des Beobachters untersucht. Dieser Mann kann alles sein.

Abgeschlossen wird der innere Monolog mit dem Satz »There will be no art.« Ob diese Behauptung als Drohung oder utopische Imagination zu verstehen ist, ob eine Gesellschaft ohne Kunst der Verrohung der Kultur geschuldet ist oder keine mehr benötigt, da sie frei von Konflikten ist, bleibt dahingestellt. Willie Doherty jedoch verbindet die Kritik politischer Realität mit derjenigen an der Repräsentation dieser Realität. Das Ergebnis ist die utopische Kraft der Kunst: im klassischen Sinn Aufklärung über Bilder durch Bilder. Unpolemisch und unpathetisch ist seine Kunst ein Anwalt der Verständigung: »At the end of the day it's a new beginning.«

[1] Vgl. Niklas Luhmann, *Die Realität der Massenmedien*, Opladen 1996, S. 9.

[2] Vgl. die Kritik von Michael Wilson in: *Artforum International*, XLV, 7, 03/2007, S. 314: »... they [Die beiden Darsteller des Films] seem to have some felonious, or at least nefarious, purpose in mind.«

At the End of the Day It's a New Beginning
Matthias Mühling

Ever since video images came of age they have been used for surveillance—to keep tabs on prisoners and to detect shoplifters—but also in public spaces in the interests of prevention. A camera's eye watches whatever moves on city streets and squares and on public transportation. Monitoring, recording, and policing are the order of the day. Simply being out and about makes one a suspect.

Willie Doherty's half-hour video installation *Blackspot* (1997, p. 88) shows a section of a city with streets, houses, vehicles, and people on the move. Cars drive by, people leave houses, walk down a street, or return home. Slowly it gets dark. Night falls. The scene grows less and less clear. Details fade with the failing light. Then everything starts over: the video loop repeats the process *ad infinitum*. But what looks peaceful is, suggests the title, a problem zone, a "blackspot." Where danger is aboard, so too is surveillance.

The video camera was mounted on the historic city walls in Derry, Northern Ireland. The location is part of the Bogside, the district where, in 1969, the "Battle of the Bogside" sparked off the "troubles" and where three years later "Bloody Sunday" took place. The artist installed his lens where British Army surveillance cameras are still positioned, using a strategic hill site to secure a view of the potential battlefield with technical images. The camera's mere presence is a show of power. As such it is no innocent device and ever since Marey's invention of the "chronophotographic rifle," has been likened to a gun. Indeed, wherever it serves military intelligence it is still a weapon—not a lethal one, yet it can wound. It purports to observe objectively and incorruptibly, but the mere act of observing contaminates the very process with the taint of suspicion.

For when human beings observe others, their intentions are always ideologically motivated. What the camera records is always interpreted. The simple act of opening a door and entering can arouse suspicion. The camera's presence contaminates with potential transgression of what is otherwise banal. Simply to appear within its focal range incriminates. There is no way out of this camera-object constellation. The popular argument that the innocent have nothing to hide is itself ideologically corrupt. For even an innocent man may have something he wants to hide, for instance, his private life.

Like *Blackspot,* many of Doherty's video pieces deal with the omnipresence of politically instrumentalized images. Doherty's images, however, show us how little we really know about the things we see in the media. He demonstrates how this is used to generate evidence where nothing is, in fact, evident. Those images that are cloaked in impartiality are particularly dangerous because they conceal their political intent so well. The more successfully they achieve this, the more powerfully they can manipulate. Since time immemorial images have served potentates—Pharaohs, Caesars, French kings—as instruments of political propaganda,

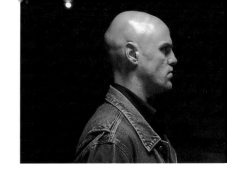

only today technical images and the mass media have increased the possibilities enormously. For instance, a suggestive caption under the photograph of a human face can make a hero of that person—or a monster.

Same Difference (1990, p. 44) shows two identical slides of a woman's face from a television news broadcast. Words are projected on top of the images of this nameless person. The caption over the first image reads "Murderer," that over the second, "Volunteer." These designations are then qualified by various adjectives (p. 46), so that one sequence, for instance, becomes "BARBARIC, MURDERER, MERCILESS, MURDERER," the other "DEDICATED, VOLUNTEER, HEROIC, VOLUNTEER."

The juxtaposition of image and caption familiar in the mass media is thus described as a principle whereby the semantic power of the written word prevails. The written word is intent on subjugating the visual. Regardless of what a face may elicit in us, it is dominated by the letters that make up its caption. If the letters spell "murderer," one inclines to see a murderer, if "volunteer," then a volunteer. But by constantly switching epithets, and thus interpretations, Doherty reduces the principle to absurdity. A face is not an open book in which, like the early physiognomists, we read characteristics as if they were words. Rather the viewer's perspective influences what he wants to see. Who becomes a volunteer or a murderer is not always decided legally—what is more important is the political orientation of the viewer who will discern such and such an attribute, or its opposite. Willie Doherty draws attention to this aspect of the political instrumentalization of images, focusing on how media propaganda functions.

The conflict in Northern Ireland is the backdrop to Doherty's works. It is the world he grew up in, inhabits, and has known for decades. Thus, while his visual world is to an extent politically and geographically specific, not least in the Irish accents heard in his voiceovers, his videos go way beyond local political references. What makes them outstanding is their ability to handle, at a general level and with immense subtlety, topics such as societal mechanisms of inclusion and exclusion as well as ethnic, colonial, and religious conflicts. Meanwhile, at the aesthetic level, drawing on opposing spheres of authenticity and fiction, Doherty develops filmic strategies that integrate references from genres as diverse as action film and documentary.

The filmic argumentation employs a dual strategy, analyzing both aesthetic and thematic issues with a subtlety that extends beyond the particular to almost every conflict rooted in colonialism or the aftermath of colonialism throughout the world. Common to all these conflicts is the concealment of colonial and geopolitical interests under a cloak of religious irrationalism. The opponent's arguments tend to be demonized as religious fanaticism. Seen from afar, the issues become increasingly obscure because they are always conveyed by the media, in other words secondhand.

As remarked by Niklas Luhmann at the beginning of *The Reality of the Mass Media* (1996): "Whatever we know about our society, or indeed about the world in which we live, we know through the mass media."[1] As if history did not exist, only images, news, and discourse thereon. It is clear that complex issues are subjected to simplification. Not only do the media

simplify topics in order to make them more intelligible, they also transform them into "news" to satisfy the interest of readers or television viewers. Arguments become arguments for the camera. Our image of the Northern Ireland conflict, or of the war in Lebanon, in 2006, is shaped almost exclusively by news images. Few are directly involved. Clichés abound in the news in much the same way as in art. Thus, analysis of how the mass media process reality is also always integral to Doherty's photographs and videos. At another level, they reveal the extent to which media-generated prejudices dominate how we interpret images.

Passage (2006, p. 148) shows two men walking from opposing directions, as if to meet each other. This takes place at night, close to a motorway, the sounds of which can be heard in the background, in an otherwise undefined no-man's land. Cutting back and forth between the two subjects dramatically foregrounds their approach. The viewer awaits a climactic encounter. But what actually happens is unspectacular. At the last moment, the men notice each other. Then, as they pass, they look back over their shoulders at each other (fig. p. 153). Variations follow, the repeated drama of their encounter remains undramatic. Montage alone generates suspense. Tension results not from narrative facts but from the narration's filmic properties.

A critic writing in Artforum remarked that the men seem to have mischief in mind.[2] This is not accurate. It is not the men who have something in mind, but the viewers who ascribe it to them. Men who walk down deserted streets at night must be conscious that others will think that they are up to no good. However, it is not the misinterpretation of images that is fatal, but the fact that political and media propaganda reach into our daily lives. We are contaminated by prejudices. In certain situations we experience others not as fellow human beings but as potential threats. Just as the two men in the film view each other with suspicion, then we also have no alternative but to view the film with uncertainty. Our expectations are dictated not by firsthand experiences, but by secondhand, mediated ones.

This theme comes to a head in Doherty's Many Have Eyes but Cannot See (2001, p. 114), a two-minute video installation comprising two close-ups of the artist's left and right eye. Having been separately filmed, they move independently of each other as they apparently focus on objects and actions concealed from the observer. The title comes from a mural in Derry's Bogside depicting the media as a blindfolded figure, alluding to their strategic inability, or unwillingness, to see the British injustices committed in Ireland. At the same time Many Have Eyes but Cannot See functions as a kind of self-portrait, where the artist, reduced to a pair of eyes, stands for the quintessentially human. For it is in the human countenance, especially the eyes, that feelings and qualities of character are concentrated. Traditionally seen as the "mirror of the soul," what these eyes observe, how they interpret it, and how it is processed by the psyche is left to the viewer's imagination. What is not shown cannot be represented and so remains outside of the frame and hidden.

The faces of the protagonists in Same Difference, Passage or Many Have Eyes but Cannot See may hint at their thoughts, yet there is never certainty. In other works the contrast between the face and the internal world of the subject plays a conspicuous role. In Non-Specific

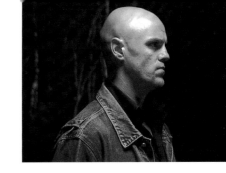

Threat (2004, p. 136) and *Closure* (2005, p. 142), for instance, the human image and voiceover counterpoint each other. In *Closure* we see a woman dressed in black, circling around an area fenced off by metal barriers. A parallel American (i.e. from approximately the hip upward) tracking shot follows the woman's movements, while at regular intervals close-ups of her face are cut in (fig. pp. 145, 147). A voiceover invokes the woman's purposefulness ("My purpose is clear," "My endurance is constant"), or alludes to the destruction of undefined objects vaguely associated with interior spaces ("The crack is splitting," "The glass is shattered"). The poetic effect of the voice lends itself to the rhythm of the images. An emotionally dramatic, yet indefinable mood is palpable and pervasive.

Non-Specific Threat, on the other hand, consists of a continuous tracking shot around a young man standing alone in a deserted warehouse. As the camera circles the filmed subject, we hear a voiceover. It switches between different perspectives as it invokes the non-specific threat of the title ("I am the reflection of all your fears," "Your death is my salvation") or a utopian state ("I will make your dreams come true"). Although barely perceptible, the man's facial movements are extremely expressive, and together with the internal voice's suggestive comments, seem to wed the inner and outer, the physical and mental. Projected states of latency and eruption, violence, and sexuality alternate; only hinted at bodily, they assume form via the spoken word. The future seems to be something that will unfold ominously. The voice speaks of disappearances, of absences that will one day prevail: "There will be no oil," "There will be no music." Causal connections are left up to the viewer to project. Language and image combine brilliantly to explore the relations between reality and fiction, the depicted man's subjectivity and that of the viewer. This man can be everything.

The inner monologue ends with the sentence "There will be no art." Whether this is to be understood as a threat or as a utopian vision, whether an artless society results from cultural impoverishment, or whether it needs no art because all conflicts have been banished, is moot. Willie Doherty, however, brings together the critique of political reality and the critique of the representation of that reality. The result is the visionary power of art in the classical sense, where images instruct us about images, unpolemically and without pathos. As such his art is an advocate of understanding: "At the end of the day it's a new beginning."

[1] Niklas Luhmann, *The Reality of the Mass Media* (Cambridge and Oxford, 2000), p. 1.

[2] Michael Wilson, in *Artforum International* XLV, 7 (2007), p. 314: "[T]hey [the two actors in the film] seem to have some felonious, or at least nefarious, purpose in mind."

Yilmaz Dziewior im Gespräch mit Willie Doherty

Yilmaz Dziewior Eine Freundin aus Israel behauptete kürzlich einmal, Konflikte erzeugten Kreativität. Das meinte sie sicher nicht romantisch, sondern aus einem analytischen, wenngleich optimistischen Blickwinkel. Aus der Perspektive eines Menschen, der sich einmischen und etwas verändern will. Erinnerst du dich daran, wann du dich dazu entschlossen hast, Künstler zu werden? Glaubst du, dass dich dazu auch die besondere gesellschaftliche und politische Situation motiviert hat, in der du lebtest?

Willie Doherty Ich habe mich zunächst mit der mir aufregend erscheinenden Möglichkeit befasst, Kunst zu machen, und dem darin liegenden Potenzial, die durch die von der frühen Punk-Musik in den 1970er-Jahren ausgehende Energie in gewisser Weise mit meinem eigenen Leben zu tun hatten. Der Punk bedeutete für mich damals Veränderung und eine Form autonomer Betätigung. Diese Haltung empfand ich als befreiend, und als ich schließlich die amerikanische Pop-Art entdeckte, habe ich beides miteinander verbunden. Außerordentlich prägte mich dabei die Art und Weise, wie in diesen Arbeiten banale Bilder des Alltags verwendet wurden.

Das genügte für meine Entscheidung, Kunst zu studieren, und als ich es an die Akademie geschafft hatte, erkannte ich, dass ich bei der Produktion von Kunstwerken die Dinge, die außerhalb dieser Institution auf der Straße passierten, nicht einfach ignorieren konnte. Mein letztes Jahr als Student war geprägt von dem Druck und der Gewalt rund um die Hungerstreiks der IRA. Bobby Sands starb, während wir unsere erste Ausstellung vorbereiteten. Ich versuchte die Bedeutung des politischen Konflikts, in dem ich mich befand, und darüber hinaus den Zweck des Kunstmachens zu begreifen. Der politische und mein eigener innerer Konflikt zwangen mich, darüber nachzudenken, was ich als Künstler tun sollte.

YD Als Student hast du eine Diaprojektion mit Bildern von Landschaften und Kindheitserinnerungen geschaffen. Standen diese Bilder bereits in einem Verhältnis zum politischen Konflikt in Irland?

WD Diese Arbeit hatte einen autobiografischen Bezug. Ich glaube, das ist nicht ungewöhnlich bei den Arbeiten junger Künstler. Die Bilder, die ich damals verwendete, waren Teil eines Denkprozesses hinsichtlich der Art und Weise, wie ich weitermachen sollte. Ich versuchte mir über mein Verhältnis zum Ort und der Tradition künstlerischer Beschäftigung mit der Landschaft klar zu werden. Diese Arbeit bildete den Ausgangspunkt meines Versuchs, den romantischen, nationalistischen Umgang mit Land oder Natur in der irischen Kultur zu hinterfragen. Dabei entwickelte ich mit Hilfe der Fotografie ein Mittel zur Untersuchung der Landschaft als politisches Konstrukt.

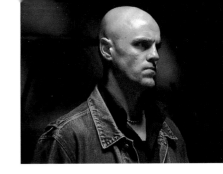

YD Bei der Vorbereitung deiner Arbeit *30 January 1972* (1993, S. 54 ff.) befragtest du Augenzeugen des so genannten »Bloody Sunday« nach ihren Erinnerungen. Zum Zeitpunkt dieses Ereignisses warst du erst zwölf Jahre alt und wurdest selbst Zeuge der Erschießung von Menschen. Für mich klingt ein solches Unterfangen nicht nur sehr persönlich, sondern gleichzeitig höchst analytisch, weil hier die Wahrheit der von den Medien verbreiteten Bilder in Frage gestellt wird. Was motivierte dich zu dieser Arbeit?

WD Ich glaube, meine Motivation war eher analytischer als persönlicher Art. Ich war neugierig darauf zu erfahren, wie man sich an Ereignisse erinnert, beziehungsweise sie vergisst, insbesondere so traumatische wie dieses. Das singuläre Vorkommnis bestimmte ja den Lebenslauf sehr vieler Menschen und hatte direkte Auswirkungen auf Heftigkeit und Dauer des Krieges in Nordirland. So gesehen, kam ihm der Status eines bestimmenden, ja nahezu mythischen Moments zu.

Als Augenzeuge habe ich nicht den geringsten Zweifel daran, dass an diesem Tag unschuldige Menschen ermordet wurden. Allerdings begann ich nach so vielen Jahren, meiner eigenen Erinnerung zu misstrauen, und wollte daher eine Arbeit machen, die sich mit diesem Phänomen des Vergessens winziger Einzelheiten und/oder des Glaubens an eine bestimmte Fassung der Wahrheit beschäftigte. Damit, in welcher Weise Medienbilder zu beherrschenden Bildern werden, die andere Formen des Erinnerns ersetzen oder zumindest beschönigen.

YD 2002 warst du als Vertreter Großbritanniens auf der Biennale in São Paulo. Im Jahr 2007 wirst du Nordirland auf der Biennale in Venedig vertreten. Die bei solchen Veranstaltungen propagierte nationale Identität stellt immer ein gewisses Problem dar. Für dich als Künstler, der aus Nordirland kommt, muss das umso mehr der Fall sein. Wie denkst du darüber?

WD Ich glaube, für viele Künstler ist die Identifikation ihrer Kunst mit der oft vereinfachenden Vorstellung einer nationalen Identität eher problematisch. Im Allgemeinen empfinde ich es als frustrierend, wenn man meine Arbeit nur im Kontext der Zugehörigkeit zu einer bestimmten Nationalität oder einem bestimmten Ort betrachtet. Deshalb muss man es sich jedes Mal gut überlegen, an einer Ausstellung teilzunehmen, die der eigenen Arbeit eine Vorstellung nationaler Eigenheiten aufdrückt. Ich nutze daher solche Situationen gerne als Gelegenheit, allzu simplifizierende Auffassungen davon, was etwa »britisch« oder »irisch« ist, zu konterkarieren.

Ich glaube nicht, dass ich als Vertreter Großbritanniens in São Paulo ein nahe liegender Kandidat war, sondern habe es eher so verstanden, dass der Kurator mich auswählte, um die Präsentation, dessen, was »britisch« ist, ein wenig zu verkomplizieren. Mir gefiel diese kuratorische Strategie, deshalb habe ich mich zur Teilnahme bereit erklärt. Wo ich herkomme, ist die Art und Weise, wie sich jemand selbst positioniert, immer äußerst vielschichtig. Es ist dort möglich, zwei Pässe zu besitzen und sich gleichzeitig an verschiedenen politischen und geografischen Orten aufzuhalten. Deshalb bemühe ich mich, im Kontext jeder Ausstellung die Wahrnehmungs- und Deutungsmöglichkeiten meiner Arbeit zu erweitern.

YD Wie wird der Inhalt deiner ausgesprochen politisch aufgeladenen Arbeiten in einem Kunst-kontext wahrgenommen, und wie würde man ihn demgegenüber beispielsweise im Kontext der Massenmedien auffassen? Ich könnte mir vorstellen, dass die Konfrontation des Betrachters mit einer Installation, die ihn physisch umgibt und vom Alltag abschneidet, nicht nur seine Wahrneh-mungserfahrung verstärkt, sondern auch emotional ergreifender wirkt. Gleichzeitig ist aufgrund der Verwendung einer vorformulierten Filmsprache ganz offensichtlich die Authentizität der von dir gezeigten Objekte zweifelhaft, was die emotionale Wirkung des Inhalts wiederum ab-schwächt.

WD Mein Interesse gilt dem Ausstellungsraum im Sinne eines Raums zur Betrachtung und Kon-templation. Ich habe nicht den Eindruck, dass meine künstlerische Arbeit durch die restriktiven Zusammenhänge von Produktion und Präsentation behindert wird, mit denen ich zu kämpfen hätte, wenn ich in den Mainstream-Medien arbeiten würde. Die Möglichkeiten der physischen Interaktion des Betrachters mit der Installation in einem Ausstellungsraum ließen sich in einer anderen Situation nur sehr schwer verwirklichen. Diese Erfahrung vermittelt eine Intensität, die sich von der beim Betrachten eines Films in einem Kinosaal deutlich unterscheidet. Beides hat zwar miteinander zu tun, doch mir gefällt, dass der Betrachter sich selbst durch den Ausstel-lungsraum bewegen und sowohl mit passiven wie auch mit aktiveren Arten des Sehens be-schäftigen muss.

 In mancherlei Beziehung ähnelt das dem Verhältnis meiner Bilder zur vorformulierten Filmsprache. Ich meine damit, dass die Bilder offensichtlich inszeniert und konstruiert sind und »filmisch« wirken, aber gleichzeitig doch anders mit Zeit und Raum umgehen. Schließlich wer-den die Arbeiten in Echtzeit und im realen Ausstellungsraum wahrgenommen, auf den sie sich beziehen. Sie fordern den Betrachter nicht dazu auf, sich zur Aushebelung jeden Zweifels an der Authentizität des Dargestellten lediglich mit einem fiktiven Raum und einer fiktiven Zeit zu be-schäftigen.

YD In einem früheren Gespräch erwähntest du, dass du auf das Video *Non-Specific Threat* (2004, S. 136 ff.) Reaktionen aus der »gay community« erhieltest, die deine Arbeit aus einer schwulen Perspektive deutete. In *Passage* (2006, S. 148 ff.), einer nach *Non-Specific Threat* entstandenen Videoinstallation, sieht man, wie zwei Männer nachts einen einsamen Weg ent-lang laufen, aneinander vorübergehen, sich dann umdrehen, um sich gegenseitig zu mustern. Man könnte die Handlung auch als eine Art des »Cruising«, der Partnersuche im Schwulenmi-lieu, deuten. Für mich erweitert diese mögliche Lesart den engen Kontext, in welchem deine Arbeiten gewöhnlich betrachtet werden. Warst du dir der Möglichkeit einer schwulen Auslegung deiner Videos bewusst?

WD Ich freute mich darüber, dass man *Non-Specific Threat* auch aus einer schwulen Perspek-tive betrachtete. Irgendwie ist es ja auch offensichtlich. Ich war mir während der Entstehung der

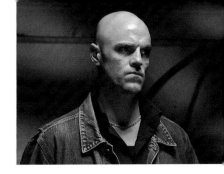

Arbeit einer solchen Lesart durchaus bewusst. *Non-Specific Threat* beschäftigt sich ja mit der Projektion unserer Ängste und Sorgen auf ein unbekanntes Anderes.

Meine Verwendung des Skinhead-Typs rührt daher, dass mir aufgefallen war, wie nordirische Paramilitärs sich in der Nähe zu rassistischen Neonazi-Gruppen positionieren. Die Tatsache, dass der kahl geschorene Kopf auch als eine Art Zeichen für Schwulsein wahrgenommen wird, ist interessant im Kontext einer gegen Männer gerichteten männlichen Gewalt, die ein wesentlicher Bestandteil des Nordirlandkonflikts ist. Allgemeiner betrachtet, ist das Bild des gesetzlosen Schlägers eines von vielen Stereotypen, die in den Medien häufig zur Personifizierung unserer Angst vor einem möglichen Zusammenbruch der gesellschaftlichen Ordnung oder der Ausweitung des Terrorismus bemüht werden. Meine Entscheidung, mit diesem Darsteller zu arbeiten, verdankte sich außerdem der Tatsache, dass er in einem Fernsehfilm schon einmal eine ähnliche Rolle gespielt hatte.

Die Rezeption meiner Arbeiten ist mir ein wichtiges Anliegen und das, was du als den »engen Kontext« bezeichnest, in dem sie wahrgenommen werden. Die erwähnte Installation *Passage* etwa versuchte ich in einem jener Zwischenräume zwischen Wissen und Erwartung anzusiedeln, die mein Werk umgeben. Die Absichten und Motive der beiden Typen werden hier bewusst im Dunkeln gehalten, so dass die »Cruising«-Deutung als eine von verschiedenen Möglichkeiten vorstellbar wird. Seit einiger Zeit bemühe ich mich verstärkt darum, den Bereich der meine Arbeit bestimmenden Referenzen stärker zu erweitern, so dass es irrelevant wird, ob der Betrachter über ein Vorwissen hinsichtlich meiner Praxis oder des historischen beziehungsweise politischen Gehalts des Entstehungsortes verfügt.

YD In welchem Verhältnis stehen in deinen Werken die gesprochenen oder geschriebenen Texte zu den bewegten Bildern? Abgesehen von Arbeiten wie *30 January 1972* oder *True Nature* (1999, S. 102 ff.), in denen du Auszüge aus eigenen Interviews zitierst, sind die Texte von dir selbst verfasst, oder? Sie wirken gleichzeitig poetisch und brutal. Zuweilen lesen sie sich wie Gedichte oder Fragmente einer Kurzgeschichte. Interessierst du dich für jüngere Literatur, etwa für das Werk eines Seamus Heaney oder anderer irischer Autoren?

WD Die Texte stammen von mir selbst; manchmal sind sie die Reaktion auf die Bilder, manchmal gehen sie ihnen aber auch voraus. Während meine Bilder häufig auf filmische oder dokumentarische Genres verweisen, sind die Texte oftmals fiktiven oder journalistischen Quellen entnommen oder beziehen sich auf diese. Insofern verfolge ich eher einen pragmatischen als einen poetischen Ansatz, wenn ich sie verfasse. Ich betrachte meine Texte in derselben Weise als Fragmente, wie man die Videos als Fragmente, als kurze Ausschnitte aus einem wesentlich längeren Film, betrachten kann.

Ich habe vor vielen irischen Autoren und ihrem gewaltigen Beitrag zur Weltliteratur die allergrößte Hochachtung, empfinde mich allerdings über meine Rolle als Leser hinaus nicht als Teil dieser Welt. Mein Umgang mit Texten ist eher strategisch und entspringt einer vom Kubis-

mus bis zur Konzeptkunst reichenden Traditionslinie von Künstlern, die Text in unterschiedlichster Form in ihre Werke integrieren.

YD Du verfolgst in deinen Arbeiten sehr häufig eine Doppelstrategie. Bei den von dir dargestellten Szenen und Menschen könnte es sich häufig sowohl um Bedrohende *als auch* um Bedrohte, um potenzielle Mörder *und* Opfer handeln. Du kombinierst also nicht vereinbare Perspektiven. Dies ist insofern ein höchst interessanter Ansatz, als er zugleich These und Antithese beinhaltet, ohne aber auf die befreiende Synthese hinauszulaufen, mit der sich das Problem lösen oder zumindest erklären ließe. Handelt es sich hierbei um eine bewusste Entscheidung aufgrund der Themen, mit denen du dich beschäftigst?

WD Es ist eine bewusste Strategie, die sich aus meinen frühen Fotoarbeiten entwickelt hat, die mit Text operierten. In diesen Arbeiten sollte es nicht lediglich um die Frustration gegenüber dem Medium und der Unzuverlässigkeit von Fotografie gehen, sondern um die Einschränkungen hinsichtlich des Umgangs mit den komplexen Problemen eines äußerst umstrittenen politischen Gebiets. Diese Strategie wurde in den Dia- und Videoinstallationen weiter entwickelt. In Arbeiten wie *Same Difference* (1990, S. 44 ff.), *The Only Good One Is a Dead One* (1993, S. 58 ff.), *Re-Run* (2002, S. 126 ff.) und dem erwähnten *Non-Specific Threat* habe ich versucht, offensichtlich unmögliche und unter Umständen moralisch zweifelhafte Positionen einzunehmen.

Die Erfahrung, in einer Konfliktsituation zu leben, versetzt einen in die Lage, mit unterschiedlichen Reaktionen auf komplizierte Sachverhalte umgehen zu müssen. Die hinter einem Gewaltakt stehenden Motive zu begreifen und dabei gleichzeitig seine Folgen zu verabscheuen. Die Angst vor der Möglichkeit anzuerkennen, Opfer von Gewalt zu werden und auf Rache zu sinnen. Jemanden als Nachbarn, Freund oder Verwandten zu kennen und gleichzeitig als Opfer oder Täter. Es gibt keine neutrale Position, da man durch den Zufall der Geburt oder des Wohnorts selbst von den Umständen betroffen ist.

Insofern zeichnet sich der Standpunkt oder die Stimme meiner Arbeiten weniger durch Neutralität oder den Versuch aus, einen Mittelweg zu finden, als vielmehr durch das Bemühen, mit den Komplexitäten des Lebens in einer Welt umzugehen, die uns gleichzeitig bedroht und mit einschließt.

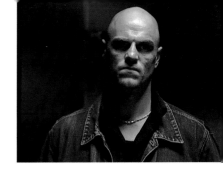

Yilmaz Dziewior in Conversation with Willie Doherty

Yilmaz Dziewior A friend of mine from Israel recently said that conflicts create creativity. She did not mean this in a romantic way, but rather from an analytic—though optimistic—point of view. The point of view of someone who wants to get involved and change things. Do you remember the moment when you decided to become an artist? Do you think you, too, were motivated by the specific social and political situation you were living in?

Willie Doherty I first became engaged and excited about the possibility and potential for making art that felt connected to my life through the energy of early punk music in the 1970s. At that time, for me, punk was about change and doing things for yourself. I found that attitude liberating, and when I discovered American Pop art, I put the two things together. I was very inspired by how that work used imagery from the banal stuff of everyday life.

 That was enough to make me want to go to art school, and when I got there I found that when it came to making art, I could not ignore the things that were happening on the streets outside of the institution. My last year at college was dominated by the tension and violence surrounding the Republican hunger strikes. Bobby Sands died while we were putting the finishing touches to our final exhibition. I struggled to find a way of making sense of the political conflict that I found myself in and the purpose of making art. The political conflict and my own internal conflict forced me to really consider what I should do as an artist.

YD As a student you constructed a slide projection with images of landscapes and childhood memories. Were these images already related to the political conflict of Ireland?

WD This work had an autobiographical dimension. I think that this is quite common in the work of young artists. The images that I was using at that time were part of my process of working out how to proceed. I was trying to resolve issues around my relationship to place and the tradition of making work about the landscape. This work was the start of my attempts to question the romantic, nationalist engagement with the land or nature in Irish culture. I was developing a means, through photography, of interrogating the landscape as a political construct.

YD For the preparation of your piece *30 January 1972* (1993, p. 54) you asked eyewitnesses to Bloody Sunday what they have seen. At the time the event took place you were twelve and had witnessed people being shot. To me, undertaking a piece like this sounds not only very personal, but at the same time very analytic because it questions the truth of images disseminated by the media. What was your motivation to do this piece?

WD I think my motivation was more analytical than personal. I was curious about how events are remembered or forgotten, especially such traumatic events as Bloody Sunday. This single event shaped the course of many people's lives and impacted upon the intensity and the longevity of the war in the North of Ireland. As such, it was afforded the status of defining moment, an almost mythical event.

As an eyewitness, I have absolutely no doubt that innocent people were murdered on that day. However, after so many years I began to mistrust my own memory and wanted to make a work that was concerned with this process of forgetting the small details and/or believing a version of the truth; how mediated images become the dominant images and replace or embellish other forms of remembering.

YD You represented Great Britain in the São Paulo Bienal, in 2002, and will represent Northern Ireland in Venice, in 2007. National identity as promoted in events like this is always problematic. It must be even more so considering your own position as an artist coming from Northern Ireland? What do you think about this?

WD I think that for many artists the identification of their art with an often simplistic idea of national identity is highly problematic. In general, I find it frustrating when my work is only considered within the context of nationality or place. So, to participate in any show that maps an idea of nationality onto the work has to be considered very carefully. I try to look at these occasions as an opportunity to disrupt an easy reading of Britishness or Irishness or whatever. I don't think that I was an obvious choice as the artist to represent Britain in São Paulo, and I recognized that the curator had chosen me in order to complicate how Britishness was being presented. I appreciated this curatorial strategy and therefore agreed to participate. I come from a place where how one positions oneself is always extremely layered. A place where it is possible to have two passports and to be in different political and geographical spaces simultaneously. So I am always happy to look at each exhibiting context for opportunities to expand how my work can be seen and understood.

YD How is the content of your highly politically charged work perceived in an artistic context versus, for example, how it would be perceived in public media? I could imagine that by confronting the viewer with an installation that physically surrounds and isolates the person from the everyday, it intensifies not only the experience of perception, but is also more emotionally involving. At the same time by using the pre-existing language of cinema, it is clear that the authenticity of the things you show is in doubt and therefore the content could be less affecting?

WD I am interested in the kind of space for viewing and contemplation that the gallery allows. As an artist I don't feel that my work is bound by the rather restrictive contexts of production and presentation that I would have to contend with if I worked within the mainstream media. The way

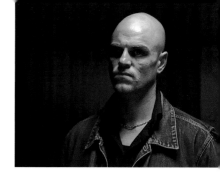

in which the viewer can physically interact with the installation in the gallery would be very difficult to achieve in another situation. There is an intensity about this experience that is different from the experience of watching a film in the shared space of a cinema. They have some common characteristics, but I like how the viewer has to negotiate her way through the gallery space and has to engage with both passive and more animated modes of looking.

In some ways this is similar to the relationship my images have with the pre-existing language of cinema. By this I mean that the images are clearly staged and constructed and feel "cinematic," but at the same time they have a different way of dealing with space and time. Ultimately, the work is experienced in, and more concerned with, the real time and space of the gallery and does not ask the viewer to deal only with fictional space and time, to suspend disbelief.

YD You mentioned in a conversation we had earlier that on *Non-Specific Threat* (2004, p. 136) you received reaction from the gay community, which was interpreting the piece from a queer perspective. In *Passage,* a video installation created after *Non-Specific Threat,* two young men walk at night, along a lonely path, pass each other, and then turn around to look at each other. The action could be read, among other things, as a kind of cruising. To me the possibility of this reading broadens the tight context in which your work is usually viewed. Were you aware of the potential of the works to be read from a queer perspective?

WD I was very happy that *Non-Specific Threat* was read from a queer perspective. In a way it is so obvious. Such a reading was something that I was conscious of at the time of making the work. *Non-Specific Threat* is concerned with how we project our fears and anxieties onto an unknowable other.

My use of the skinhead type had come from looking at how some Northern Irish paramilitaries have positioned themselves closely with racist and neo-Nazi groups. The fact that the shaved head is also perceived as some kind of signifier of gayness is interesting in the context of the male on male violence that characterized much of the conflict in Northern Ireland. In a broader sense, the image of the lawless thug is one of a number of stereotypes that are often used in the media to personify our fears about an imagined breakdown of social order or increase in terrorism. My decision to work with this actor was partly motivated by the fact that he had been cast in a similar role in a television drama.

I am very concerned with how my work is read and what you call the tight context within which the work is seen. *Passage* (2006, p. 148) is an attempt to allow the work to exist in some of the gaps between knowledge and expectation surrounding my work. The intentions and motivations of the two guys are deliberately undisclosed within the work, so that the "cruising" reading is only one of a number of possibilities that come to mind. For some time, one of my concerns has been to expand the field of references that surrounds my work so that it is not necessary for the viewer to have any previous knowledge of my practice or of the historical or political context of the site of its production.

YD How do you see the relation of the spoken or written texts in your installations to the moving images? Besides works like *30 January 1972* or *True Nature* (1999, p. 102), where you quote parts of interviews you conducted, the texts are written by you. Your texts are at once poetic and abrasive. They sometimes read like poems, or a sort of fragmented short story. Are you interested in current literature, such as Seamus Heaney's work, or that of other Irish writers?

WD The texts are written by me, sometimes in response to the images and sometimes in advance of the images. In the way that my images often reference cinematic or documentary genres, the texts are often appropriated from or reference fictional or journalistic sources. In that way my approach to writing the texts is more pragmatic than poetic. I think of the texts as fragments in the way that the videos can be seen as fragments, short scenes from a much longer movie. I have the utmost respect for many Irish writers and the enormous contribution that they have made to world literature. I don't feel that I am part of that world, other than as a reader. My own use of text is more strategic and comes out of an tradition of artists using text in various ways as a component within the artwork, from Cubism to Conceptualism.

YD Very often you use a dual strategy in your work. The scenes and people you show could very often be both threatening *and* threatened, possible murderers *and* victims. So you combine viewpoints which are incommensurable. This is a very interesting approach because it employs thesis and antithesis, but without resulting in the enfranchising synthesis which is solving the problem or explains the reason for it. Is this a very conscious decision because of the issues you are dealing with?

WD This is a conscious strategy that evolved from my early photograhic works with text. These works attempted to deal not only with my frustration with the medium itself, the unreliability of the photograph but with its limitations in terms of dealing with the complexities of a highly contested political terrain. This strategy has been further developed in the slide and video installations. Works such as *Same Difference* (1990, p. 44), *The Only Good One Is a Dead One* (1993, p. 58), *Re-Run* (2002, p. 126), and *Non-Specific Threat* attempt to embrace apparently impossible, and perhaps morally dubious, positions.

The experience of living in a conflict situation puts one in the position of having to deal with different responses to difficult circumstances. To sympathize with the motivation behind and act of violence and to be abhorred by the consequences. To acknowledge fear of the possibility of becoming a victim of violence but to look for revenge. To know someone as a neighbor, friend, or relative, *and* as a victim or a perpetrator. There is no position of neutrality, one is implicated by the accident of birth or the choice of address.

Therefore the position or voice that emerges within my work is not one of neutrality, of trying to occupy the middle ground, but one that tries to deal with the complexities of living in a world where one is both compromised and implicated.

Videografie Videography

Same Difference 1990

Diainstallation mit Doppelbildprojektion (Unikat)
Two screen slide installation (Unique)
Erstaufführung First shown at Matt's Gallery, London
Courtesy Arts Council Collection, Southbank Centre, London

Auf zwei identische Dias von einem aus den Fernsehnachrichten abfotografierten Frauengesicht, auf die beiden gegenüberliegenden Wände eines dunklen Raums geworfen, werden zwei verschiedene Wortreihen projiziert. Durch die erste wird die Frau als MÖRDER(IN) … GNADEN-LOS(E) … MÖRDER(IN) … FEHLGELEITET(E) … MÖRDER(IN) … BÖSE und so weiter ausgewiesen. Die zweite Wortfolge charakterisiert sie als FREIWILLIG(E) … SENTIMENTAL(E) … FREIWILLIG(E) … NOSTALGISCH(E) … FREIWLLIG(E) … WILD(E) und so fort. Jede Abfolge umfasst einige identische Wörter, wodurch gewährleistet ist, dass hin und wieder auf beiden Gesichtern gleichzeitig dieselben Wörter erscheinen können.

 Same Difference zeigt, wie sehr unsere Projektion eines Charakters auf ein Bildnis davon abhängig ist, wie Sprache zur Kontextualisierung eines Gesichts verwendet wird. Hier geht es um die beunruhigende Frage, wie sich politische Positionen herausbilden können, wenn die Informationsmöglichkeiten durch Zensur weiter eingeschränkt werden.

Two identical slides of the face of a woman, photographed from a television news broadcast, are projected onto two diagonally opposite walls of a dark space. Two different sequences of words are projected on top of these images. One sequence identifies her as MURDERER … PITILESS … MURDERER … MISGUIDED … MURDERER … EVIL, etc. The other identifies her as VOLUNTEER … SENTIMENTAL … VOLUNTEER … NOSTALGIC … VOLUNTEER … WILD, etc. Each sequence contains a number of identical words, ensuring the possibility that at some point the same words are superimposed over each face simultaneously.

 Same Difference demonstrates that our projection of character onto a portrait is heavily dependent upon the way in which language is used to contextualize that face and addresses the more unsettling question of how political positions are formed when censorship further limits the possibility of what can be known.

Same Difference 1990

MURDERER	VOLUNTEER	MURDERER	VOLUNTEER
DELIRIOUS	DARING	WILD	WILLING
MURDERER	VOLUNTEER	MURDERER	VOLUNTEER
IMPULSIVE	FEARLESS	MYTHICAL	PERSISTENT
MURDERER	VOLUNTEER	MURDERER	VOLUNTEER
AGGRESSIVE	EMBITTERED	COOL	ADVENTUROUS
MURDERER	VOLUNTEER	MURDERER	VOLUNTEER
SAVAGE	ANGRY	OBSESSED	EXPERIENCED
MURDERER	VOLUNTEER	MURDERER	VOLUNTEER
GROTESQUE	EMOTIONAL	EVIL	DISCREET
MURDERER	VOLUNTEER	MURDERER	VOLUNTEER
REPULSIVE	INTUITIVE	PERFECT	DEDICATED
MURDERER	VOLUNTEER	MURDERER	VOLUNTEER
PRIMITIVE	MELANCHOLIC	WICKED	PATIENT
MURDERER	VOLUNTEER	MURDERER	VOLUNTEER
UNSPEAKABLE	MYTHICAL	RELENTLESS	CALM
MURDERER	VOLUNTEER	MURDERER	VOLUNTEER
REVOLTING	SENTIMENTAL	COMMITTED	METICULOUS
MURDERER	VOLUNTEER	MURDERER	VOLUNTEER
NAUSEATING	NOSTALGIC	DAMNED	LOYAL
MURDERER	VOLUNTEER	MURDERER	VOLUNTEER
PITILESS	ROMANTIC	EMBITTERED	EXCEPTIONAL
MURDERER	VOLUNTEER	MURDERER	VOLUNTEER
MISGUIDED	IMPULSIVE	ODIOUS	PERFECT
MURDERER	VOLUNTEER	MURDERER	VOLUNTEER
COWARDLY	TEMPESTUOUS	CALLOUS	DISTINGUISHED
MURDERER	VOLUNTEER	MURDERER	VOLUNTEER
SHAMEFUL	INFATUATED	RUTHLESS	HEROIC
MURDERER	VOLUNTEER	MURDERER	VOLUNTEER
SICKENING	PASSIONATE	CALCULATING	SWORN
MURDERER	VOLUNTEER	MURDERER	VOLUNTEER
MERCILESS	NATURAL	LOYAL	NOBLE
MURDERER	VOLUNTEER	MURDERER	VOLUNTEER
DERANGED	UNTAMED	PERSISTENT	DEFIANT
MURDERER	VOLUNTEER	MURDERER	VOLUNTEER
INTUITIVE	BEAUTIFUL	SWORN	HONOURABLE
MURDERER	VOLUNTEER	MURDERER	VOLUNTEER
BARBARIC	FANATICAL	DEDICATED	COMMITTED
MURDERER	VOLUNTEER	MURDERER	VOLUNTEER
INNATE	WILD		

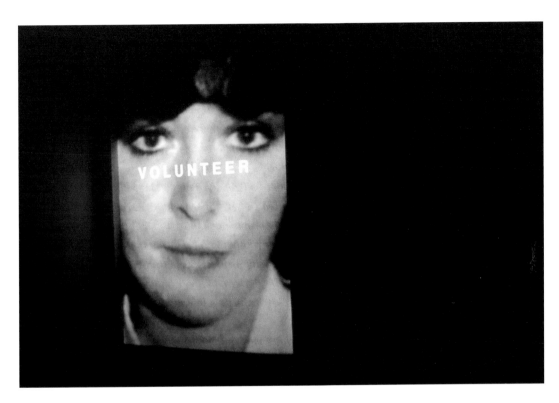

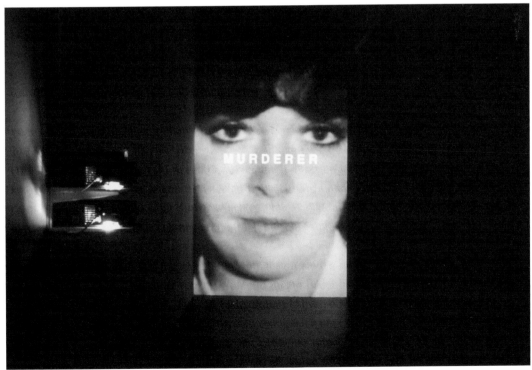

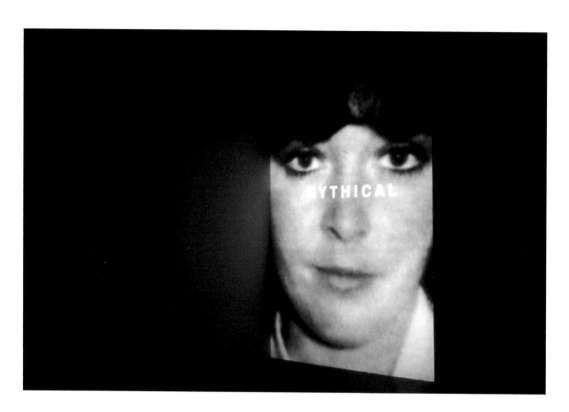

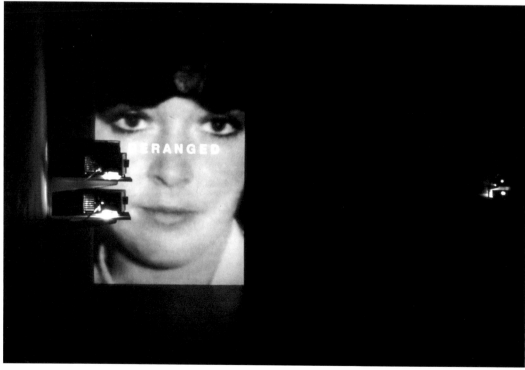

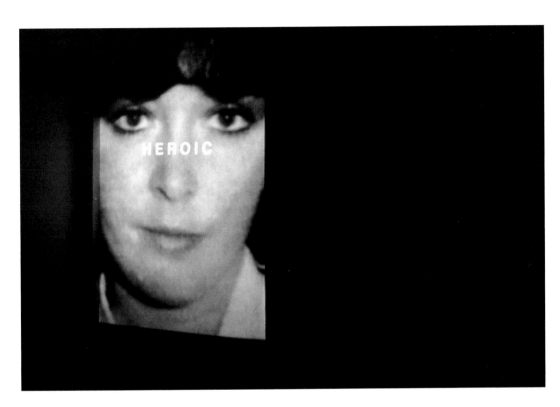

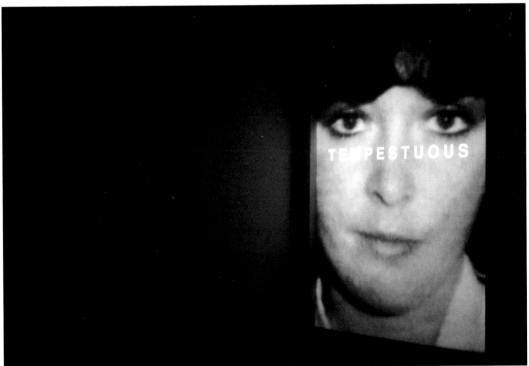

They're All the Same 1991

3 min., Ton, Diainstallation mit Einzelbildprojektion (Unikat)

3 minutes, sound, single screen slide installation (Unique)

Erstaufführung First shown at Laing Art Gallery, Newcastle-upon-Tyne

Courtesy In the collection of Sammlung Goetz, München Munich

They're All the Same ist der Titel einer 35-mm-Diaprojektion mit Ton. Sie zeigt das Gesicht eines in sich selbst versunken scheinenden jungen Mannes mit gesenktem Blick. Das Bild des Mannes wurde aus einer Zeitung abfotografiert, sodass die einzelnen Punkte des Farbtrennungsrasters sichtbar sind. Der Off-Text wird von einem Mann mit leichtem irischen Akzent gesprochen.

Der gesprochene Monolog weist eine Doppelstruktur auf, da der Erzähler von der irischen Landschaft spricht, die, in Ausdehnung auf seinen Charakter, als von Natur aus wild und unbezähmbar beschrieben wird. Der Text enthält außerdem eine Reflexion über die Vorstellung einer ungeteilten mythischen Nation/Wildnis im Sinne einer motivierenden Kraft. Beim Versuch, beide »Ichs« darzustellen (Ich bin anständig und ehrlich … – Ich bin unzivilisiert und ungebildet) wird die Stimme schließlich von Selbstzweifeln geplagt.

They're All the Same consists of a 35mm slide projected onto a freestanding screen with an accompanying audio track. The projection is of the face of a young man who appears introspective, with his eyes cast downwards. The image of the man has been photographed from a newspaper and the dots of the color separation process are visible. The voiceover is spoken by a man with a soft Irish accent.

The spoken monologue presents a dual structure as the narrator speaks about the Irish landscape, which is described as an extension of his character, as innately wild and untameable. The text also speculates about the concept of an undivided mythic nation/wilderness as the force that motivates him. In the end, the voice is riddled with self-doubt as he struggles to present both "selves" (I am decent and truthful … I am uncivilized and uneducated).

Sprecher Voiceover Artist Dave Duggan

Ton Sound Recordist Michael Bradley

Tonschnitt Sound Editor Michael Bradley

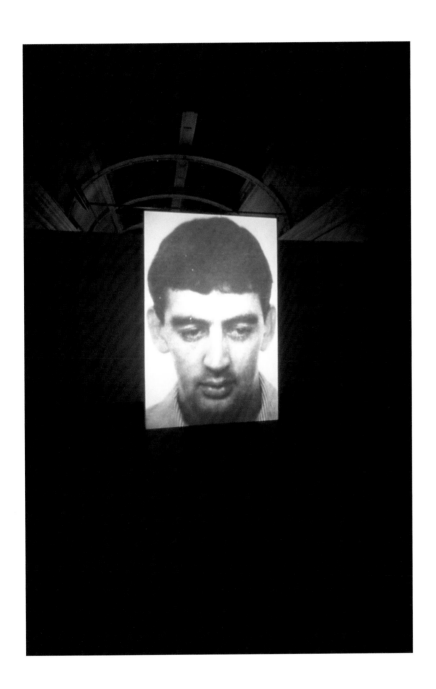

They're All the Same 1991

The clean sweet air is interrupted only by the lingering aroma of turf smoke.
I'm pathetic.
The verdant borders of twisting lanes are splattered with blood-red fuschia.
I'm barbaric.
Nowhere is the grass so green or so lush.
I'm decent and truthful. It's in my bones.
Nowhere are the purples and blues of the mountains so delicately tinged.
I am ruthless and cruel.
Nowhere is the sea so clear and calm, and, with barely a moment's notice, the waves so dark and angry.
I am solid.
Nowhere has the sky such a range of delicate blues and mysterious grays.
I am essentially evil.
The sky is at its most dynamic in the west, where it is contrasted sharply against the white limestone walls.
I never saw such walls.
They represent the blood and sweat of countless generations. For all this land is "made" land, hand made.
I am proud and dedicated.
For me, there is no alternative.
Upon seeing the gray barrenness of this limestone country one of Cromwell's generals complained,
"There is not enough timber to hang a man, enough water to drown him, or enough earth to bury him."
I am uncivilized and uneducated.
On a clear day, when there is no haze to obscure the view, it is possible to gaze across the open landscape.
I have its history in my bones and on my tongue.
It's written all over my face.
Rain or shine, there are few landscapes whose color, scale, and contrast impress so immediately.
I'm crazy.
Nowhere are the nights so dark.
So dark that you cannot see the end of the road.
I'm innocent.
I'm cynical.
Nowhere is the sand on the beaches so fine and white.
I am patient. I have a vision.
Smooth, age-worn stones wet with rain.
Even the rain is different there.
The soft Atlantic rain which often seems to cover the whole country adds depth and subtlety to its color.
I am dignified.

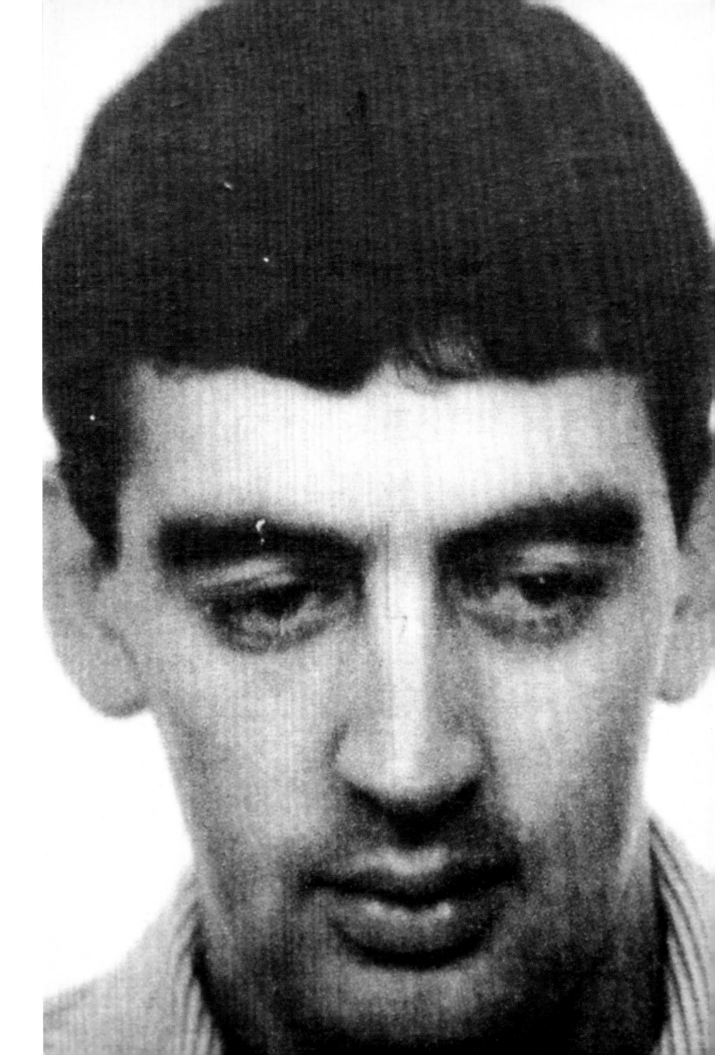

30 January 1972 1993

3 min., Ton, Diainstallation mit Doppelbildprojektion (Unikat)
3 minutes, sound, two screen slide installation (Unique)
Erstaufführung First shown at The Douglas Hyde Gallery, Dublin
Sammlung des Künstlers Collection of the artist

30 January 1972 bezieht sich auf das als »Bloody Sunday« in die Geschichte eingegangene Ereignis, bei dem vierzehn unbewaffnete Zivilisten während eines Protestmarsches auf den Straßen der nordirischen Stadt Derry von britischen Fallschirmjägern erschossen wurden. Die Arbeit umfasst Archivmaterial aus dem Jahr 1972: ein 35-mm-Dia, das aus einem Fernsehnach-richtenbeitrag über die Demonstration abfotografiert wurde, sowie eine während der Schieße-reien entstandene Tonbandaufnahme. Dem gegenüber stehen ein 1993 aufgenommenes Dia von einem der Schauplätze der Schießereien sowie drei Tonaufnahmen mit bearbeiteten Samples aus Interviews, die 1993 an derselben Stelle geführt wurden.

 Die Arbeit versucht nicht, den bestehenden Indizien etwas hinzuzufügen, sondern befasst sich mit dem Prozess der Erinnerung signifikanter Ereignisse und ihrer Vermittlung über Augenzeugenberichte und unmittelbare Erfahrungen sowie mittelbares und sonstiges Bildmate-rial aus zweiter Hand.

30 January 1972 refers to the event known as "Bloody Sunday," when fourteen unarmed civilians were shot dead by British Paratroopers on the streets of Derry during an anti-interment march. The work incorporates archival material from 1972 in the form of a 35mm slide photographed from television news coverage of the protest march and an extract of a sound recording made during the shootings. These are juxtaposed with a slide of one of the sites where the shooting occurred, as it looked in 1993, and three audio tracks of edited samples of recorded interviews conducted on the same streets in 1993.

 The work does not attempt to add to the existing body of evidence, but is more con-cerned with the process by which significant events are remembered and passed on through eye-witness accounts and firsthand experience, alongside mediated and other secondhand imagery.

Tonschnitt Sound Editor Stephen Price

… I was diagnosed that day as a diabetic, ye know, and I was up in my mother's house in Creggan and
then I came down to Blucher Street and I was crossing over here to the mother-in-law's when I heard the shots
ringing out, so I ran back and hid behind the gable wall over there …

… everybody was just devastated that day …

… one of the men went out with his hands up, all of a sudden there was a crack and he just went down …

… a very good friend of ours, we all lived in the flats together, was shot that day. That was a young fella
by the name of Hugh Gilmore, and ah … I think I was the last person he spoke to, to tell me that he was hit.
"I'm hit … I'm hit!" …

… Bloody Sunday will always be Derry …

… he was lying, blankets covering him and blood was all over the place …

… I didn't know him, I didn't hear who it was, but I could see him lying and people roaring and squealing
to get down for cover …

… it was just mayhem …

… I remember the fear taking over me and getting up and running and everyone shouting to get down,
and running through the high flats and seeing the bodies lying there. Now for months after that I used to
waken up with cold sweats, at two or three in the morning … just waken up with cold beads of sweat
on me …

… people talked about how the skies were even crying …

… the only image I have about Bloody Sunday is that the people were innocent …

… Ah … it was tragic … it was tragic …

… everyone went out, I would say, in a happy mood …

… on the other side of the flats was a man lying with a sort of a banner around his head and I remember
walking over and seeing his eyelash on the wall … Somebody took it off the wall and put it in a matchbox
and put it inside his pocket …

… it was just a massacre that day …

… his companion's head exploded just like you'd see it on a film …

… he lost his shoe and there was a kind of a push forward, I think it was to see what was happening further
down the street, but we were away at the back, so I took him over to my house to get him another pair of
shoes and that's when all the shooting happened …

… one man was brought in there and when they took his jumper off part of his back fell out where he was shot

… he was shot in the back twice …

… it was a terrible day for this community as a whole and it stayed with everybody for years …

… it should never have happened …

… there was just hysteria …

… you couldn't get back into the chapel for the funeral, it was just packed out, but seeing the thirteen coffins
lined up in front of the altar the night before was very very moving …

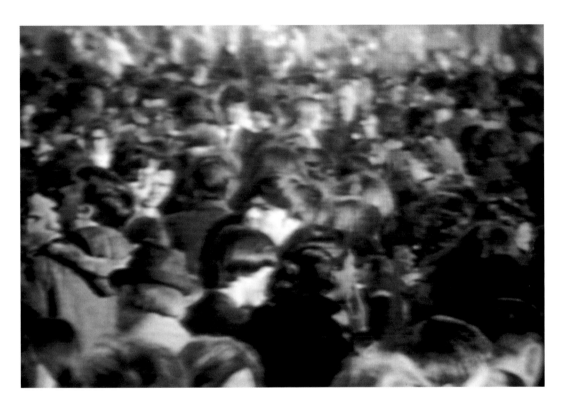

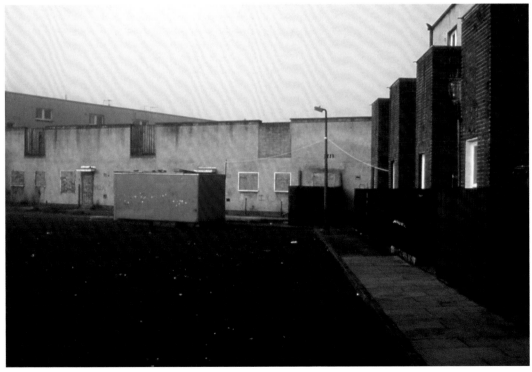

The Only Good One Is a Dead One 1993

30 min., Farbe, Ton, Installation mit Doppelprojektion (Unikat)

30 minutes, color, sound, two screen installation (Unique)

Erstaufführung First shown at Matt's Gallery, London

Courtesy In the collection of The Irish Museum of Modern Art, Dublin; Geschenk der Gift of the Weltkunst Foundation

The Only Good One Is a Dead One besteht aus zwei separaten Projektionen, die gleichzeitig auf den beiden gegenüberliegenden Wänden eines dunklen Raums zu sehen sind. Das erste Bild zeigt das mit subjektiver Kamera aufgenommene Innere eines Autos, das eine nächtlich dunkle Landstraße entlangfährt. Die Szene wird lediglich von den Scheinwerfern des Autos erhellt, dessen konstantes Fahrgeräusch auf der Tonspur zu hören ist. Das zweite Bild zeigt das mit subjektiver Kamera aufgenommene Innere eines auf einer großstädtischen Straße parkenden Autos. Die Szene ist vom rötlichen Schein der Straßenlaternen erleuchtet. Beide Aufnahmen wurden in einer einzigen Einstellung gedreht und sind ungeschnitten zu sehen.

Nach wenigen Augenblicken erklingt die Stimme eines jungen Mannes, der einen sich anscheinend auf beide Szenen beziehenden Monolog spricht. Er beschreibt seine Angst davor, ermordet zu werden, sowie seine Rachegedanken und den Plan, einer anderen Person aufzulauern. Die Tonspur des sprechenden Mannes ist kürzer als die beiden Filmsequenzen, sodass Überschneidungen mehrerer Schichten aus Bildern und Wörtern entstehen, die den Betrachter zwingen, sich zwischen zwei gleichermaßen voneinander getrennten wie voneinander abhängigen Erfahrungen hin und her zu bewegen.

The Only Good One Is a Dead One consists of two separate projections, which are shown simultaneously on two opposite walls of a dark space. The first image is a point-of-view shot from the interior of a car traveling along a dark country road at night. Only the car headlights illuminate the scene, and the audio track is the sound of the car as it drives continuously. The second image is a point-of-view shot from the interior of a stationary car on an urban street at night. The scene is illuminated by the red glow of street lamps. Both sequences are recorded in one take and shown unedited.

After a few moments the voice of a young man is heard as he speaks a monologue that seems to refer to both sequences. He describes his fear of being assassinated and his desire for revenge as he plots to ambush another person. The soundtrack of the man speaking is shorter than the two video sequences and overlaps to create a layering of imagery and words as the viewer is forced to move between two distinct but mutually dependant experiences.

Sprecher Voiceover Artist Paul McLoone

Ton Sound Recordist Stephen Price

Kamera Camera Elaine Farthing

The Only Good One Is a Dead One 1993

I worry about driving the same route everyday … Maybe I should try out different roads … alternate my journey.
That way I could keep them guessing.
I don't remember now when I started feeling conspicuous … A legitimate target.
I've been watching him for weeks now. He does the same things every day … Sadly predictable, I suppose.
The fucker deserves it.
We've known about him for a long time but we've been waiting for the right moment. Waiting for him to make
a move.
I keep thinking about this guy who was shot … I remember his brother said "We were both sitting having
a cup of tea watching the TV when I heard this loud bang at the front door … We both jumped up to see what it
was, he was nearer the door than me and got into the hall first … But by that time the gunman was also in the
hall and fired three or four shots directly at him … point-blank range … I'm lucky man because then he panicked
and run out to the street where a car was waiting for him."
Sometimes I feel like I'm wearing a big sign … "SHOOT ME." As far as I'm concerned he's a legitimate target.
The only good one is a dead one.
If I'd had the shooter earlier I could have had him a dozen times. Dead easy! … I've walked right up behind him,
looked straight at the back of his head … He was wearing a checked shirt and faded jeans … He didn't even
notice me and I walked straight past him.
I'm certain that my phone's bugged and that someone is listening to my conversations …
Every time I lift the receiver to answer a call I hear a loud click … as if someone else is lifting the phone
at the same time … I'm not imagining it because some of my friends also hear this strange noise when they
call me … My anxiety increases when my phone rings occasionally in the middle of the night. This is totally
inexplicable as no one would want to ring me at three or four in the morning … It scares the hell out of me …
I think that my killer is ringing to check if I'm at home.
He reminds me of someone … Maybe someone I went to school with.
I feel like I know this fucker … I know where he lives, his neighbors, his car … I'm sick of looking at him.

I saw a funeral on TV last night. Some man who was shot in Belfast. A young woman and three children standing crying at the side of a grave. Heartbreaking.

One morning, just before I left home at half six, I heard a news report about a particularly savage and random murder … That's how I imagine I will be shot … as I drive alone in the dark I visualize myself falling into an ambush or being stopped by a group of masked gunmen. I see these horrific events unfold like a scene from a movie …

I was very relieved when dawn broke and the sky brightened to reveal a beautiful clear winter morning.

He drives the same road every day, buys petrol at he same garage … It'll be easy. No sweat!

I can't stop thinking about the awful fear and terror he must have felt … Maybe it was so quick he didn't know a thing. I can almost see myself waiting for him along the road. It's fairly quiet so it should be safe to hide the car and wait for him as he slows down at the corner …

A couple of good clean shots should do the job.

This particular part of the road is very shaded. Tall oak trees form a luxurious canopy of cool green foliage … The road twists gently and disappears at every leafy bend.

As my assassin jumps out in front of me everything starts to happen in slow motion. I can see him raise his gun and I can't do a thing. I see the same scene shot from different angles. I see a sequence of fast edits as the car swerves to avoid him and he starts shooting. The windscreen explodes around me. I see a clump of dark green bushes in front of me, illuminated by the car headlights. The car crashes out of control and I feel a deep burning sensation in my chest.

In the early morning the roads are really quiet … You can drive for ages without passing another car … The landscape is completely undisturbed and passes by like some strange detached film. It might be just as easy on the street … I could wait until he's coming out of the house or I could just walk up to the door, ring the bell and when he answers … BANG BANG! … Let the fucker have it.

It should be an easy job with a car waiting at the end of the street … I've seen it so many times I could write the script. In the past year I've had some really irrational panic attacks … There is no reason for this but I think that I'm a victim.

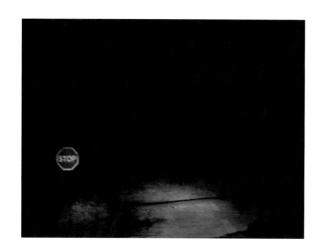 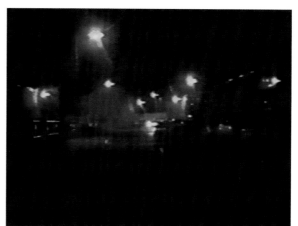

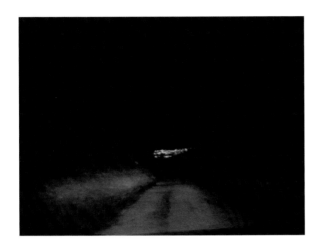 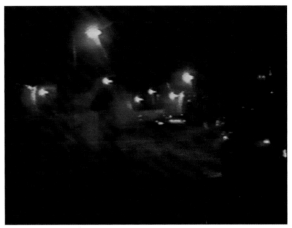

At the End of the Day 1994

10 min., Farbe, Ton, Installation mit Einzelprojektion (Unikat)
10 minutes, color, sound, single screen installation (Unique)
Erstaufführung First shown at The British School at Rome
Courtesy In the collection of the Arts Council of England, London

Bei *At the End of the Day* handelt es sich um eine einteilige Videoinstallation, die unmittelbar auf die Wand eines abgedunkelten Raums projiziert wird. Eine Kamera ist so im Innern eines Autos angebracht, dass sie einen statischen Blick durch die Windschutzscheibe liefert. Der Wagen fährt in der Abenddämmerung eine kurze Strecke auf einer kleinen Landstraße entlang. Man hört das Fahrgeräusch auf der unebenen, holprigen Straße. Der Blick fällt auf eine Beton-Straßensperre, und als das Auto das Hindernis erreicht, hält es an, wobei das Licht der Scheinwerfer auf die Betonblöcke fällt. Der Wagen bleibt an der Straßensperre stehen, bis die Spannung von einer männlichen Stimme zerrissen wird, die einen kurzen Satz sagt. An diesem Punkt wird an den Anfang zurückgeblendet, und die Szene wiederholt sich, um jedes Mal mit einer anderen Phrase zu enden.

At the End of the Day is a single-channel video installation projected directly onto a wall of a dark space. A video camera is mounted in the interior of a car to provide a static shot through the windscreen. The car travels a short journey along a small country road at dusk. The sound of the car is audible as it moves along the uneven and bumpy road. A concrete border roadblock comes into view and when the car reaches this obstruction it stops, illuminating the concrete blocks in the headlights. The car waits at the roadblock until the tension is broken by a male voice that speaks a short phrase. At this point, the sequence cuts back to the start and is repeated each time ending with a different phrase.

Sprecher Voiceover Artist Paul McLoone
Ton Sound Recordist Stephen Price

At the End of the Day 1994

At the end of the day there's no going back.

We're all in this together.

The only way is forward.

We have to forget the past and look to the future.

We're entering a new phase.

Nothing can last forever.

Let's not lose sight of the road ahead.

There's no future in the past.

At the end of the day it's a new beginning.

Let's not repeat the mistakes of the past.

No Smoke Without Fire 1994

10 min., Farbe, Ton, Installation mit Einzelprojektion (Unikat)
10 minutes, color, sound, single screen installation (Unique)
Erstaufführung First shown at the Museo Nacional Centro de Arte Reina Sofia, Madrid
Sammlung des Künstlers Collection of the artist

No Smoke Without Fire beginnt unvermittelt mit der Fahrt einer Handkamera über eine ausgedehnte Brachlandfläche. Die nächtliche Szene wird nur von einer an der Kamera befestigten Leuchte erhellt, die langsam den Boden inspiziert und über hohes Gras, Sträucher, Hausmüll und andere ausrangierte Gegenstände schwebt. Der enge Blickwinkel ändert sich nur selten und wird lediglich von einigen plötzlichen Schnitten und Aufwärtsschwenks unterbrochen, wenn sich die Kamera einem Drahtzaun nähert. Ihr Blick wendet sich schnell vom Zaun ab und fährt fort, den Boden zu untersuchen, was den Betrachter ratlos zurücklässt, ob die Handlung sich innerhalb oder außerhalb des eingezäunten Bereichs abspielt.

No Smoke Without Fire is a single-channel video installation projected directly onto a wall of a dark space. It begins abruptly as a hand-held camera moves through an extensive area of waste ground. It is night and the scene is lit only by a lamp attached to the camera, which moves at a slow pace, surveying the ground and hovering above tall grass, bushes, pieces of domestic waste, and other discarded objects. This narrow point of view rarely changes and is interrupted only by some sharp edits and when the camera tilts up as it approaches a wire fence. The camera pulls away quickly from the fence and continues to examine the ground, leaving the viewer in a state of uncertainty about whether the action is occurring inside or outside of the fenced area.

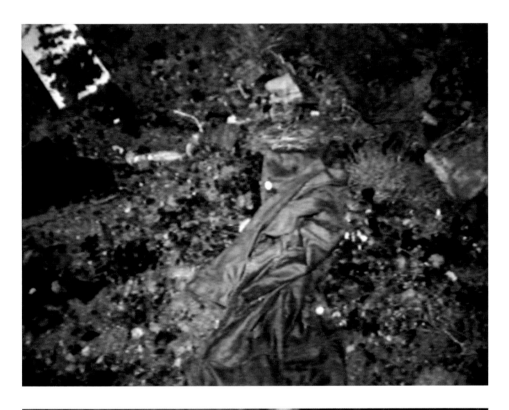

Factory (Reconstruction) 1995

10 min., Farbe, Ton, Installation mit einem Monitor (Auflage: 3)
10 minutes, color, sound, single monitor installation (Edition of 3)
Erstaufführung First shown at Kerlin Gallery, Dublin
Sammlung des Künstlers Collection of the artist

Ein Monitor zeigt die Aufblende zu einer statischen Aufnahme des heruntergekommenen Innenraums einer verfallenen Fabrik. Man hört, wie jemand Metall über den Boden schleift. Nach einigen Minuten tritt eine männliche Person von links ins Bild. Sie trägt große Schutt- und Trümmerteile und scheint eine gewisse Ordnung in das Chaos der zerstörten Fabrik bringen zu wollen. Der Mann setzt diese anscheinend nicht durchführbare Aufgabe fort, auch als er sich aus dem Bild hinausbewegt und das Geräusch seiner Anstrengung noch hörbar ist, während der Bildschirm dunkel wird.

A monitor fades up to a static shot of the devastated interior of a derelict factory. The sound of someone dragging metal is audible out of shot. After several minutes a male figure enters the left frame. He moves large pieces of rubble and debris, and appears to be attempting to create some sense of order among the chaos of the destroyed factory. He continues with this seemingly impossible task even after he moves out of frame, and the sound of his efforts is still audible as the screen fades.

Darsteller Cast Lawrence McBride

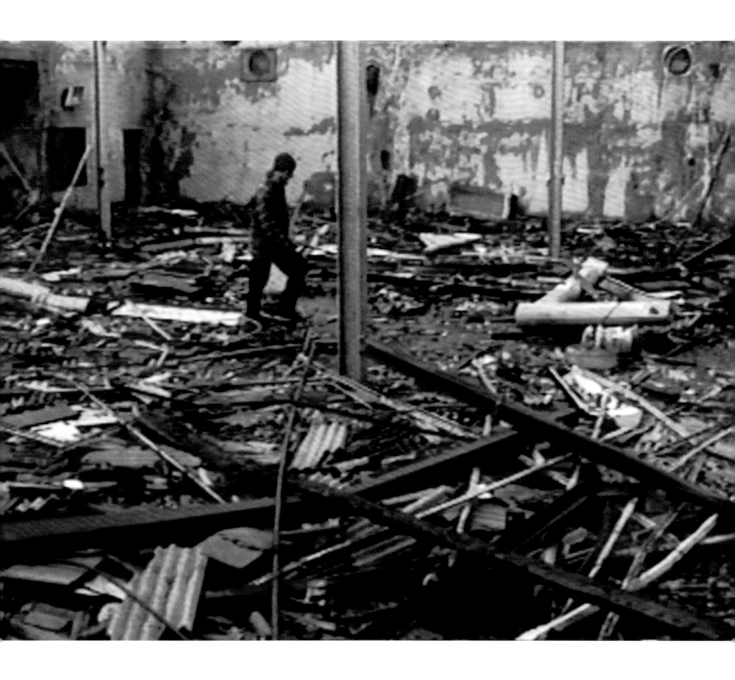

The Wrong Place 1996

10 min., Farbe, Ton, Installation mit Einzelprojektion (Unikat)

10 minutes, color, sound, single screen installation (Unique)

Erstaufführung First shown at ARC, Musée d'Art Moderne de la Ville de Paris

Bei *The Wrong Place* handelt es sich um eine einteilige Videoinstallation, die unmittelbar auf die Wand eines abgedunkelten Raums projiziert wird. Der Film beginnt bei Dunkelheit und Stille, die jäh endet, als ein Lichtschalter betätigt wird und ein von unten aufgenommenes summendes Neonlicht flackernd aufleuchtet. Im nächsten Moment erfolgt ein plötzlicher Schnitt zu einer mit subjektiver Kamera gefilmten Fahrt eine Treppe hinunter durch ein altes, leer stehendes Gebäude. Der fremde Ort wird nur von einer Kameraleuchte erhellt, welche lediglich die unmittelbare Umgebung in Licht taucht und dabei Hinweise auf eine Nutzung des Gebäudes offenbart (Zigarettenkippen, weggeworfene Kleidungsstücke und andere Spuren, welche auf einen Unterschlupf oder ein Versteck schließen lassen). Man hört lediglich das Geräusch von Schritten, das gleich bleibend laute Summen des Neonlichts aus dem angrenzenden Treppenhaus und andere Umgebungsgeräusche aus dem dunklen Raum. Die Innenaufnahme wird urplötzlich durch das Geräusch laufender Schritte beendet, woraufhin die Kamera sich rasant bewegt, als versuche sie zu fliehen. Die Sequenz endet am oberen Treppenabsatz, von wo aus die Szene wieder ins Dunkel zurückfällt und ein Keuchen sowie schweres Atmen hörbar werden. Mit einem Mal flackert das Licht wieder auf, und die Kamera nimmt erneut eine ähnliche Fahrt durch denselben Raum auf. Wieder endet diese Sequenz am Beginn der Treppe, von wo aus sich die erste Szene wiederholt.

The Wrong Place is a single-channel video installation projected directly onto a wall of a dark space. The video sequence starts in darkness and in silence, both of which are abruptly ended by the sound of a light switch being turned on, and a humming fluorescent light, seen from below, flickers into life. Almost at once this scene cuts to a point-of-view shot as the camera moves down a flight of stairs and starts a disorientating and frightening journey through an old dysfunctional and abandoned building. This unknown place is lit solely by a lamp on the camera that reveals signs of use, such as cigarette butts, discarded clothing, and other traces evoking the idea of a hideout or refuge. The only sound is the noise of footsteps, the constant loud humming of the fluorescent light from the adjacent staircase, and other ambient noises from the dark space. This survey of the interior is suddenly ended by the sound of running footsteps as the camera moves frantically as if trying to escape. The sequence ends back at the top of the stairs where the scene is plunged into darkness and accompanied by the sound of panting and heavy breathing. Suddenly the light flickers on again and the camera starts a similar journey through the same space. Again this sequence ends back at the start of the stairs and the first sequence repeats.

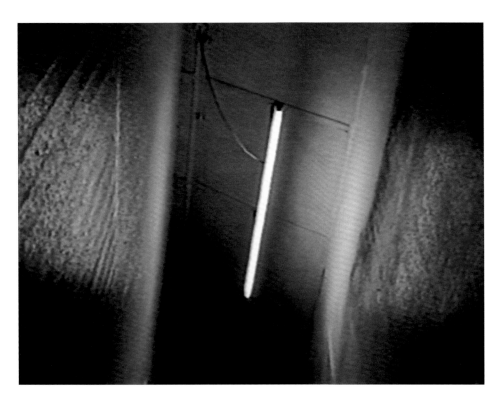

Tell Me What You Want 1996

10 min., Farbe, Ton, Installation mit zwei Monitoren (Auflage: 3)

10 minutes, color, sound, two monitor installation (Edition of 3)

Erstaufführung First shown at Galleria Emi Fontana, Mailand Milan

Courtesy In the collections of The British Council (1/3) und and Tate, London

Auf zwei Bildschirmen, die an den beiden Wänden in der Ecke eines Raums angebracht sind, erscheinen zwei verschiedene Bilder. Bei dem einen handelt es sich um die Großaufnahme einer Fahrbahn bei Nacht. Es regnet heftig, eine Straßenlaterne taucht die Szene in rötliches Licht. Man hört das Geräusch des Regens und des heulenden Windes. Auf dem anderen Monitor ist das Detail einer Landstraße mit Grünstreifen zu sehen. Es ist Tag, die Szene wird von Vogelgezwitscher und dem gelegentlichen Rauschen weit entfernten Straßenverkehrs begleitet.

Nach einigen Minuten erfolgt bei beiden Sequenzen ein Gegenschnitt auf zwei unterschiedliche Einstellungen. Die eine zeigt das Porträtfoto eines im Gegenlicht als Silhouette aufgenommenen Mannes, die andere einen ebenfalls von hinten beleuchteten silhouettenartigen Frauenkopf. Beide sprechen einen kurzen Dialog, der wie der Teil eines Drehbuchs oder der Ausschnitt aus einem Beichtgespräch klingt. Es folgt ein erneuter Schnitt auf die beiden Anfangsszenen. Dieses Muster wiederholt sich, wird allerdings durch Schwankungen in der Länge der Szenen gestört.

Two different images appear on two monitors that are mounted on two walls in the corner of a space. One is a close-up of a road surface at night. It is raining heavily and the road is lit by a street lamp that casts a red light over the scene. The sound of heavy rainfall and a howling wind accompany the scene. The other monitor shows a detail of a country road and a grass verge. It is daytime and the sound of birds singing and the occasional rumble of distant traffic accompany the scene.

After a few minutes both sequences cut to two different scenes. One is a mugshot of a man, backlit and in silhouette. The other a woman's head is similarly backlit and in silhouette. They both speak a short piece of dialogue, which sounds like it could be part of a film script or a snippet of a confessional interview. The sequences cut back to the original scenes. This pattern is repeated but is disrupted by variations in the length of each scene.

Darsteller Cast Angela Carlin, Lawrence McBride

Tell Me What You Want 1996

Man: … I never thought that it would happen to me.

You know how it is … It's always someone else. Someone you don't know.

… She didn't look like the sort of woman who would be involved in that kind of thing, was very quiet,

kept herself to herself.

I couldn't believe it when I heard she was dead. It was like a dream.

… As soon as I saw him I knew he was one of them.

He had a certain look on his face.

After that he was a fucking dead man.

… I hate walking alone in the country. I feel exposed and vulnerable. I keep thinking someone is watching me or

following me and I can't see them. I'm also frightened that I might find a body that has been hidden in the bushes.

… One night I had a dream I was taken prisoner. I was blindfolded and held in a small room. I lost all track of

time, I don't know how long I was in there. Eventually three men came into the room. They tied me to a chair and

asked me questions about my life. I thought they were going to kill me.

… I didn't know what was happening at the time. Like everyone else I read the newspaper reports and saw it

on TV. As soon as I saw the body lying in the grass I knew it was her …

I recognized the pattern of her jumper.

… I knew there was something going on even though no one was talking about it.

I could smell trouble … I could feel the tension.

I wanted to find clues … I went looking for evidence.

Look! … the photographs prove everything.

… I never thought that it would happen to me. You know how it is … It's always someone else.

Someone you don't know …

Woman: The first time I met him was in 1989, I thought he was okay but a little crazy sometimes.

But I never thought he would do that.

… You hear all kinds of stories about people being watched and their house being bugged.

I never really believed it, to tell you the truth.

I wasn't even suspicious.

I never heard any noise, never saw anything. I had no idea that there was someone listening to me … watching me.

… I never thought that it would happen to me.

You know how it is … It's always someone else.

Someone you don't know …

… Well, I was just walking down the street when I suddenly saw this guy being led away by a bunch of cops.

I didn't recognize him at the time, but I found out later who he was.

… She didn't look like the sort of woman who would be involved in that kind of thing, was very quiet,

kept herself to herself.

I couldn't believe it when I heard she was dead.

It was like a dream.

I hate walking alone in the country. I feel exposed and vulnerable. I keep thinking someone is watching me or

following me and I can't see them. I'm also frightened that I might find a body that has been hidden in the bushes.

… Her body was found dumped on a track near the border by a woman out walking at 7 am. Several hours earlier

there had been reports of shots being heard in the area.

The first time I met him was in 1989, I thought he was okay but a little crazy sometimes. But I never thought he

would do that.

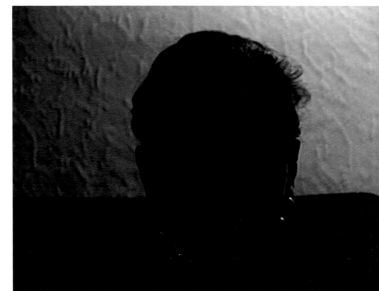

Same Old Story 1997

10 min., Farbe, Ton, Installation mit Doppelprojektion (Unikat)
10 minutes, color, sound, two screen installation (Unique)
Erstaufführung First shown at Matt's Gallery, London

Same Old Story besteht aus zwei separaten, doch parallel abgespielten Videosequenzen. Beide werden simultan auf zwei freistehende Leinwände projiziert, die in einem abgedunkelten Raum einander diagonal gegenüberstehen. Der Zuschauer wird mit dieser Arbeit in einen zyklischen, ausschweifenden Exkurs über die materiell fassbaren Motive einer zerfurchten Stadtlandschaft versetzt. Die Kamera passiert Brücken, inspiziert heruntergekommene Innenräume und untersucht die Ränder von Grünflächen. Gelegentlich tauchen flüchtige Bilder einer männlichen Figur auf, deren Identität und Absichten allerdings unklar bleiben.

 Same Old Story enttäuscht die Zuschauererwartungen an eine narrative Auflösung mittels der Hervorhebung von Projektions- und Identifikationsmechanismen. Aus den beiden Szenen wird eine Reihe voneinander losgelöster, doch allzu vertrauter Szenen über die Spuren realer und fiktionaler Gewalt, bei denen der Zuschauer aufgefordert ist, sich das zugehörige fehlende Drehbuch selber vorzustellen.

Same Old Story consists of two distinct but parallel video sequences. Both are projected simultaneously onto two freestanding screens that are positioned diagonally opposite each other in a dark space. The work positions the viewer in the middle of a cyclical and diffuse excursion through the physical motifs of a scarred urban landscape. The camera traverses bridges, surveys derelict interiors and investigates the fringes of green spaces. Occasionally, fleeting images of a male figure are provided but his identity and intention remain ambiguous.

 Same Old Story frustrates the viewer's expectations of any narrative closure by highlighting mechanisms of projection and identification. The two sequences become a series of detached but overly familiar scenes of the traces of real and fictional violence where the viewer is left to imagine the missing script.

Darsteller Cast Unbekannter Schauspieler Unknown Actor
Produktionsleitung Producer Jim Curran
Aufnahmeleitung Production Assistant Gary Rosborough
Steadycam-Assistent Steadicam Operator Brian Drysdale
Materialassistent Camera Equipment and Grip Roy Harrison, Panavision Belfast

Blackspot 1997

30 min., Farbe, Installation mit Einzelprojektion (Auflage: 3)

30 minutes, color, single screen installation (Edition of 3)

Erstaufführung First shown at Galerie Peter Kilchmann, Zürich Zurich

Courtesy In the collection of Vancouver Art Gallery (1/3)

Blackspot wurde von einer festen Kameraposition aus gedreht, die den Blick auf die Bogside außerhalb von Derry freigibt. Diese Kameraposition ahmt den Standpunkt der Überwachungs-kameras der britischen Armee nach, die an Aussichtspunkten der Stadtmauern angebracht sind. Die vorliegende Arbeit besteht aus einer dreißigminütigen ungeschnittenen Einstellung, die den Zeitraum vom Beginn der Abenddämmerung bis zur völligen Dunkelheit umfasst. Während die Szene langsam dunkler wird, liefern Straßenlaternen und die beleuchteten Fenster einzelner Häuser die einzigen Lichtquellen. Der Vorteil eines guten Überblicks durch den erhöhten Beob-achterstandpunkt wird dadurch zunichte gemacht, dass der Versuch, den Blick zu beherrschen, durch den Einbruch der Dunkelheit zu einem vergeblichen und sinnlosen Unterfangen wird.

Blackspot is a single-channel video installation projected directly onto a wall of a dark space. The footage is shot from a fixed camera position overlooking the Bogside, Derry. The camera position replicates that of British Army surveillance cameras that are located on the vantage point afforded by the city walls. The work consists of one uninterrupted, thirty-minute take that covers the period from when daylight begins to fade until darkness. As the scene slowly gets dark, street lamps and the lights in the windows of individual houses provide the only sources of light. The ability to see the scene clearly from the elevated surveillance position is diminished as darkness falls, rendering the attempt to command the view a futile and pointless exercise.

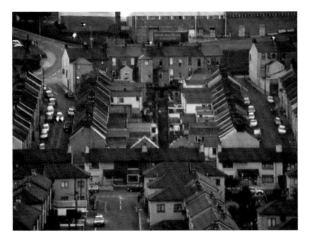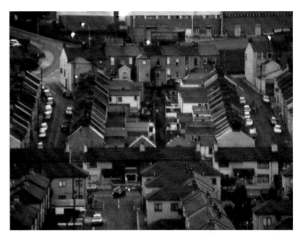

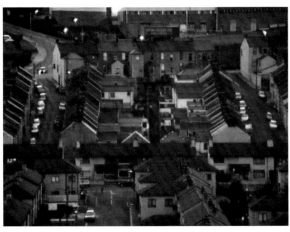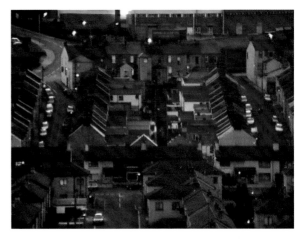

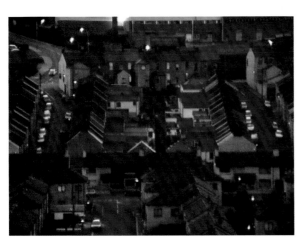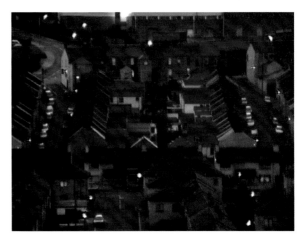

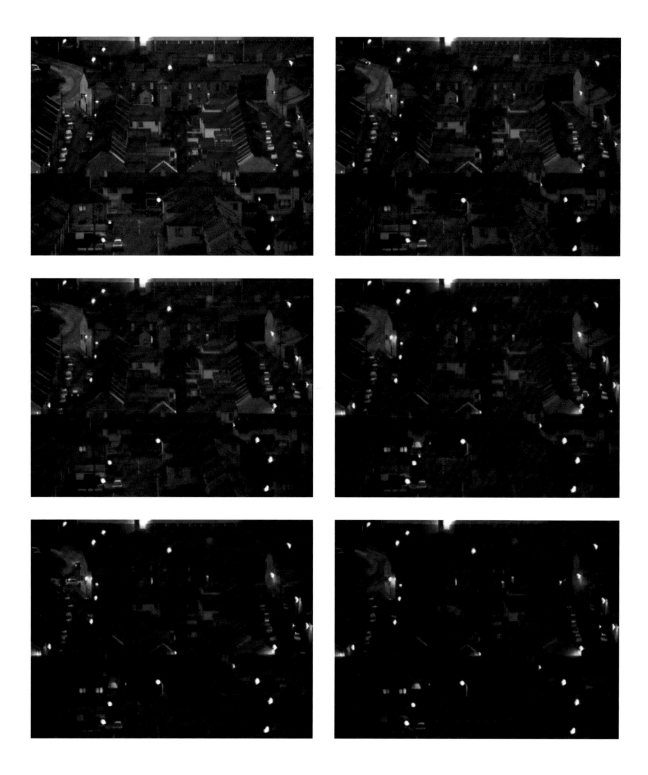

Sometimes I Imagine It's My Turn 1998

3 min., Farbe, Ton, Installation mit Einzelprojektion (Auflage: 3)

3 minutes, color, sound, single screen installation (Edition of 3)

Erstaufführung First shown at Angles Gallery, Los Angeles

Courtesy In the collections of Fonds National d'Art Contemporain, Puteaux (1/3);

Irish Museum of Modern Art, Dublin (2/3)

Bei *Sometimes I Imagine It's My Turn* handelt es sich um eine einteilige Videoinstallation, die auf eine freistehende Leinwand in einem abgedunkelten Raum projiziert wird. Der Film beginnt mit einem langsamen Kameraschwenk über ein Stück Brachland, bis die Kamera unvermittelt eine bäuchlings am Boden liegende Figur zeigt. Dieser Eingangsszene folgt unmittelbar eine Sequenz aus Dollyfahrten, die uns näher an die Figur heranführen, deren Identität stets unaufgedeckt bleibt. Die Kontinuität dieser Szene wird durch Nahaufnahmen vom Unterholz sowie kurze Einspielungen von Handkameraaufnahmen derselben Szene unterbrochen. Der wachsende Eindruck des Unbehagens wird noch verstärkt durch eingefügte Fernsehausschnitte, die eine Beziehung zwischen dem Thema des Videos und tatsächlichen Nachrichten suggerieren. Die gesamte Szene wird vom entfernten Geräusch eines Hubschraubers begleitet und endet mit einem Schwall weißen Rauschens, um sich daraufhin erneut zu wiederholen.

Sometimes I Imagine It's My Turn is a single-channel video installation projected onto a free-standing screen in a dark space. The work starts as the camera pans slowly across a stretch of waste ground and unexpectedly comes upon a figure lying face down on the ground. This establishing shot is quickly followed by a sequence of tracking shots that take us closer and closer to the figure, whose identity is never disclosed. The continuity of this sequence is interrupted by close-up shots of the undergrowth and by short inserts of handheld footage of the same scene. The growing sense of unease is further heightened by the intrusion of rapid inserts of television footage, suggesting a link between the subject of the video and actual news coverage. The overall sequence is accompanied by the distant sound of a helicopter and ends abruptly in a flash of white noise, only to repeat again and again.

Darsteller Cast Damian Nolan

Kamera Director of Photography Vinnie Cunningham

Ton Sound Recordist Billy Gallagher

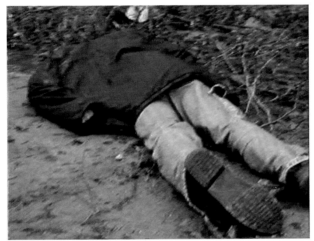

Somewhere Else 1998

10 min., Farbe, Ton, Installation mit Vierfachprojektion (Unikat)
10 minutes, color, sound, four screen installation (Unique)
Erstaufführung First shown at Tate Liverpool
Courtesy In the collection of The Carnegie Museum of Art, Pittsburgh

Somewhere Else besteht aus vier synchronisierten Videosequenzen, die gleichzeitig auf vier x-förmig zueinander angeordneten Rückprojektionsschirmen ablaufen. Jede Szene verfügt über eine eigene Tonspur. Die entsprechenden Lautsprecher sind gegenüber der jeweiligen Leinwand auf Kopfhöhe angebracht.

Die Filmaufnahmen für diese Arbeit entstanden an urbanen und ländlichen Schauplätzen in Derry und Donegal. Die geschnittenen Sequenzen wechseln unbekümmert zwischen offenbar ruhigen dörflichen Kulissen und den verwirrenden, ausgestorbenen Orten der Stadt. Der zugehörige Off-Monolog versucht, eine »einfache Geschichte mit unerwarteter Wendung« zu erklären. Allerdings wird diese »Geschichte« immer wieder durch Verweise auf die Produktion des Videos unterbrochen: »Aufblende Szene in einem Wald«, »Die Kamera folgt ihm«. Die zahlreichen unterschiedlichen Perspektiven und Wechsel zwischen Drehorten sowie die Schwierigkeit einer Fixierung der Erzählerrolle verhindern eine Auflösung oder einen Schluss der Geschichte.

Somewhere Else consists of four synchronized video sequences that are projected simultaneously onto an X-shaped configuration of four rear-projection screens. A separate soundtrack accompanies each video sequence. The speakers for each soundtrack are located at head height opposite the corresponding screen.

The footage for this work was shot in urban and rural locations in Derry and Donegal. The edited sequences move easily between apparently tranquil rural settings and the unsettling dead spaces of the city. The accompanying voiceover monologue attempts to make sense of a "straightforward story with a twist." However the "story" is punctuated with references to the production of the video: "Fade up to a scene in a forest," "The camera follows him from behind." The multiple viewpoints and shifts between locations, and an inability to fix the role of the narrator, reinforce the impossibility of resolution or closure.

Sprecher Voiceover Artist Paul McLoone
Kamera Director of Photography Vinnie Cunningham
Ton Sound Recordist Billy Gallagher

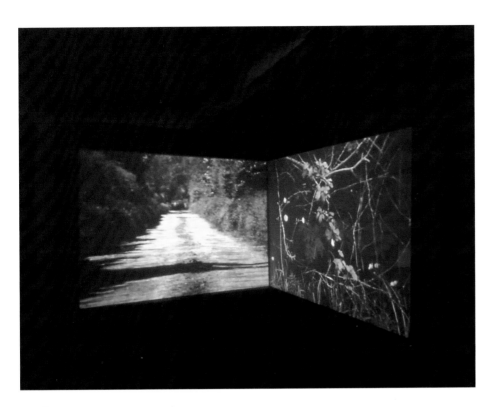

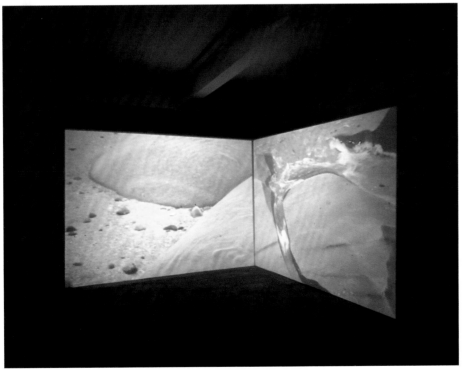

Somewhere Else 1998

Fade up to a scene in a forest.

A man walks along a cool shaded path. He moves cautiously. He has parked his car some distance away as he doesn't want to attract any undue attention. The camera follows him from behind. He comes to a small clearing in the trees and stops to listen to the distant sound of a small river. As he looks around we see him from above. A high crane shot gives us this unnatural vantage point. We see him and he doesn't even know we're watching him.

Let's start at the beginning.

It's a straightforward story, with a twist.

For the purposes of clarity, let's say it's about a man in two places at the same time.

A double life.

Who said things were going to be simple? Things are never what they seem. There's always something waiting just around the corner.

Meanwhile, he arrives for the meeting.

Fade up to a wide shot of a disused industrial landscape.

He stops the car beside a line of old storage units. As he waits his concentration slips and he remembers a dream he had the previous night.

He is in a forest.

It is the middle of the night.

He's walking towards a distant light, barely visible between the trees. As he approaches he can hear a scraping noise. Eventually he is close enough to observe two men digging a hole.

Then they drag his body from a car and throw it into the hole.

The following scene happens simultaneously somewhere else.

A nondescript stretch of country road.

The camera looks straight up the road, focused on a point somewhere in the distance. After a few minutes a car appears around a bend in the road. It continues to drive along the road, steadily getting closer and closer to the camera. Unexpectedly, the car stops and an unknown man gets out of the car and drops an unidentified object into the hedgerow at the side of the road.

He gets back into the car and drives off.

He's starting to lose it.

He struggles to keep a hold on things. A grip on reality.

His body was discovered in a foul-smelling pit full of the decomposing remains of dead farm animals. He had been beaten so badly that police were only able to identify him from one fingerprint and his dental records. Meanwhile, a helicopter hovers above the countryside, close to the border. Inside a video screen flickers with the infrared image of a ditch.

Interior. Badly furnished flat. Night.

The only light comes from the glow of a television in the corner.

He is alone, lying on a sofa, intently watching a news program. He has fantasies about getting out. He barely remembers how it all started any more, but it has got seriously screwed up. Sometimes he closes his eyes and imagines he's on a beautiful beach. Somewhere on the west coast when things were a lot simpler.

A flash of car headlights. Interior of a car. Night.

He is driving. He is trying to concentrate but sometimes it feels like his brain is splitting in two.

At the far side of the beach the soft contours of the sand are broken by huge bulks of gray rock. The rocks seem to be both an intrusion in the path of the sea and an echo of the shape of the water. Their strange forms have been created by years of exposure to the incessant patterns of the tides. One looks like the head of a shark, another snakes along the sand. Others are both familiar and unknowable.

There's been a tip-off.

Everything is in place. Nothing can ever be the same again. It's over apart from some last-minute details.

Exterior. A high vantage point overlooking the city. Dusk.

The camera is fixed on this scene with a wide angle. After five or ten minutes small dots of light begin to appear as the street lights below are switched on. Very slowly, almost imperceptibly, the camera begins to zoom in on the distant city. Gradually the frame is filled only with buildings. The long slow zoom continues relentlessly until a single window is framed neatly in the viewfinder.

He saw him recently on television.

He couldn't believe it was him. He looked for some visible sign of remorse or regret.

Nothing.

 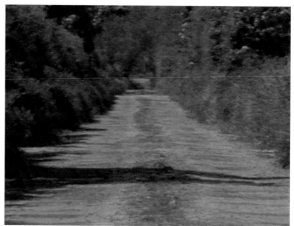

True Nature 1999

10 min., Farbe, Ton, Installation mit Fünffachprojektion (Unikat)

10 minutes, color, sound, five screen installation (Unique)

Erstaufführung First shown at The Renaissance Society, Chicago

Courtesy In the collection of The Solomon R. Guggenheim Museum, New York;

Geschenk der Gift of The Bohen Foundation, New York

True Nature besteht aus fünf simultan abgespielten Filmsequenzen. Die Videos werden auf fünf freistehende Leinwände projiziert, die es erlauben, die Bilder von beiden Seiten zu betrachten. Jede Videosequenz verfügt über eine eigene Tonspur.

Das Video- und Tonmaterial für *True Nature* wurde im August und November 1998 in Chicago und im Januar 1999 im irischen County Donegal aufgenommen. Das in Chicago gedrehte Material entstand in mehreren dem Künstler als »irisch« beschriebenen Innenstadtvierteln sowie in öffentlichen Verkehrsmitteln auf dem Weg zum beziehungsweise vom O'Hare International Airport. Gleichzeitig führte der Künstler eine Reihe von Interviews mit Angehörigen der irisch-amerikanischen Community. Sie konzentrierten sich auf ihre Vorstellung und Wahrnehmung Irlands und darauf, inwiefern diese Eindrücke von Familiengeschichten, Nachrichten und Filmen geprägt wurden. Das in Irland aufgenommene Videomaterial entstand als Reaktion auf die in Chicago geführten Interviews und bildete den Versuch, einige der dort beschriebenen Orte und Landschaftstypen »wiederzuentdecken«.

True Nature consists of five video sequences, which are shown simultaneously. The videos are projected onto five freestanding screens that allow the imagery to be viewed from both sides. A separate soundtrack accompanies each video sequence.

The video and audio material for *True Nature* was recorded in Chicago, in August and November 1998, and in County Donegal, Ireland, in January 1999. The Chicago video footage was recorded in downtown areas, in neighborhoods that were identified to the artist as "Irish," and on public transport to and from O'Hare International Airport. The artist conducted interviews with members of the Irish-American community, concentrating on their views and perceptions of Ireland and how these impressions were shaped through family stories, news coverage, and cinema. The video footage shot in Ireland was made in response to the Chicago interviews and attempted to "find" some of the places and types of landscapes described in them.

Kamera (Irland) Director of Photography (Irish Locations) Vinnie Cunningham

Ton (Irland) Sound Recordist (Irish Locations) Billy Gallagher

True Nature 1999

Narrator: He knew that he would never go back.

Woman: A lot of people in my family like to read fantasies. Science fiction and fantasies.
Woman: When she came here, she was a domestic, which means she lived with … you know, a wealthy family and took care of their children. She married late for the times, you know. That's what she used to tell me. She married when she was, I think, twenty-eight, and she was older than my grandfather. And, … you know his family disowned him because she was an immigrant, and they were old, you know, way back.
You could trace them way back, and they just thought that she was beneath him.

Man: American society is extremely mobile. You're expected to get up and go for business needs and everything else. And that is my idea for Eden, to just have a place, for better or worse that is your place, and that's my idea of Ireland …. When I see, you know, people coming from over there and … some people with a map of Ireland on their faces. And you know … you know, wide-eyed, off to the new world, to do what they can do … there's a … it's a kindred spirit. I think Irish are the most human. My grandfather was Irish … he was actually first-generation. Well, he was born there, but here when he was three years old. So, he certainly had an Irish influence because his parents were Irish. But he never much beat the drum for Ireland … but he was a talker.

Woman: It's definitely green, you know, and it's sunny and it's flat, relatively flat. That's probably from pictures I've recently seen … of Ireland. But it's … but there's a lake and it's sort of a medieval setting, you know. The castle I see is of course in ruins.

Narrator: Perhaps now he can take his place. Be one of them. He looked like one of them. He was even beginning to think like one of them.

Woman: She missed Ireland and she missed her sisters especially because … because she had all brothers.

Man: I've seen all the pictures, the photographs, and the travel posters but I've also seen the newsreels. I've also seen the barbed wires … and it's really paradoxical because the pastoral place, the Edenish place, the away place, I perceive it as NOT here … and this is a big country.
You can go virtually any physical surrounding you like in this country, but urban life in a big city, like Chicago, is a grind. You can't get any place. There's no time for anything ever. The roads are torn up forever. And you think of a better place, of all these stereotypical images of Ireland. Sure we've seen them and we say, "Oh, that would be nice."

Woman: I looked in *National Geographic* a few times and I saw my brother in a picture of Irish … I mean,
I saw my family standing there … a picture of Irish children. I saw our family.
People that, you know, we look like.

Narrator: The dark waves crashed incessantly against the rocky shore. The violent force of the sea always
fascinated him. I was both exhilarated and frightened by such power.

Woman: I was raised thinking that there's royal blood in my Irish lineage. The story is that she was jealous
of her husband's heritage. She's Polish, and she didn't have it … the same kind of pride, so she burned all the
documents, and he died at age forty-two. Actually, that was my dad's father, so I never met him. Anyway, so
there's always been this idea in the family that there's, you know, a castle somewhere for us and there's land
and a pond, a lake, and we should go see where this is, you know, this fairytale idea.

Narrator: He longed for the old, familiar places, but he knew that he had to go on.
Change was on the horizon.

Woman: I think if I went to Ireland, it would be with this sort of, and maybe this is why I haven't gone,
expectation that I would feel something if I found the place.

Narrator: Perhaps now he can take his place. Be one of them. He looked like one of them. He was even
beginning to think like one of them.

Woman: We lived with my grandmother … well, in the same apartment building, and she lived on the second
floor, so basically she was like a second mother to me. Also, she died when I was a sophomore in high school.
They were very poor, and a lot of her cousins had come here, and she knew if she came here, they would, you
know, basically set her up with a job and a place to live.
Narrator: When things got really complicated, he closed his eyes and thought of what it must've been like long
ago. He imagined himself in a place so remote that there was no other visible sign of life.

Narrator: Everything was going well. He could not accept this as he was afraid that someone would eventually
discover the truth about him … his true nature.

Man: My father was a drinker. Never an alcoholic, just a drunk. Quit when he wanted to and not quit when he
wanted to. When he got old and grey and the doctors said "Quit, you're going to kill yourself," he just stopped.
The magician. [Laughs] But it's … in my family, we are not wealthy people. There was sort of a secret pride that

no matter what your circumstances were, your group, the group … was acceptable. We cared about each other. Not in any demonstrable way. It was a safe place.

Woman: I'm a quarter Irish, a quarter Polish, a quarter Norwegian, a quarter English. So why do I feel this pull toward my Irish heritage?

Narrator: Here he could be his true self. For the first time, he was in control. He would never apologize again.

Woman: Her real name was Bridget but when she came to America, she didn't want to be identified as Bridget because it was a derogatory term like Paddy. So she changed it to Mary. Not, I don't think, legally.

Man: They carry this sense of, they betray this sense of "I'm Ireland." Ireland isn't back there. If you took all the people off Ireland, there would be no Ireland.

Narrator: When things got really complicated, he closed his eyes and thought of what it must've been like long ago. He imagined himself in a place so remote that there was no other visible sign of life.
Woman: It's the color, you know … what stays in your mind is what you want to believe, and what you want to believe is this is a beautiful green place because you left it. And you want to remember. When you go back there to visit, it's gonna be what you hope. So, I think what sticks is the romantic images.

Man: Being Irish gives you the opportunity to be half hero, half traitor and then you have the option and the excuse.

Narrator: It had been such a long and difficult journey No one could imagine the suffering he had endured. He had arrived at last, but the only problem was that he was still haunted by an inexplicable fear of screwing things up, or behaving like he had in the past. Sometimes he felt that he was doomed to never escape.

Woman: All the Irish-Americans I know are … you know, they have a lot of pride. I would say more so than a lot of other nationalities about and … maybe that's not true. But, it's really funny. It does seem to be.

Man: You can have an Irishman tell you a horror story and make you laugh by the way he tells it. Between the bejesuses he's throwing in, and the … then, you know, being thrown out by bouncers and being chased by the police. It's always a laugh. It's always a lark.

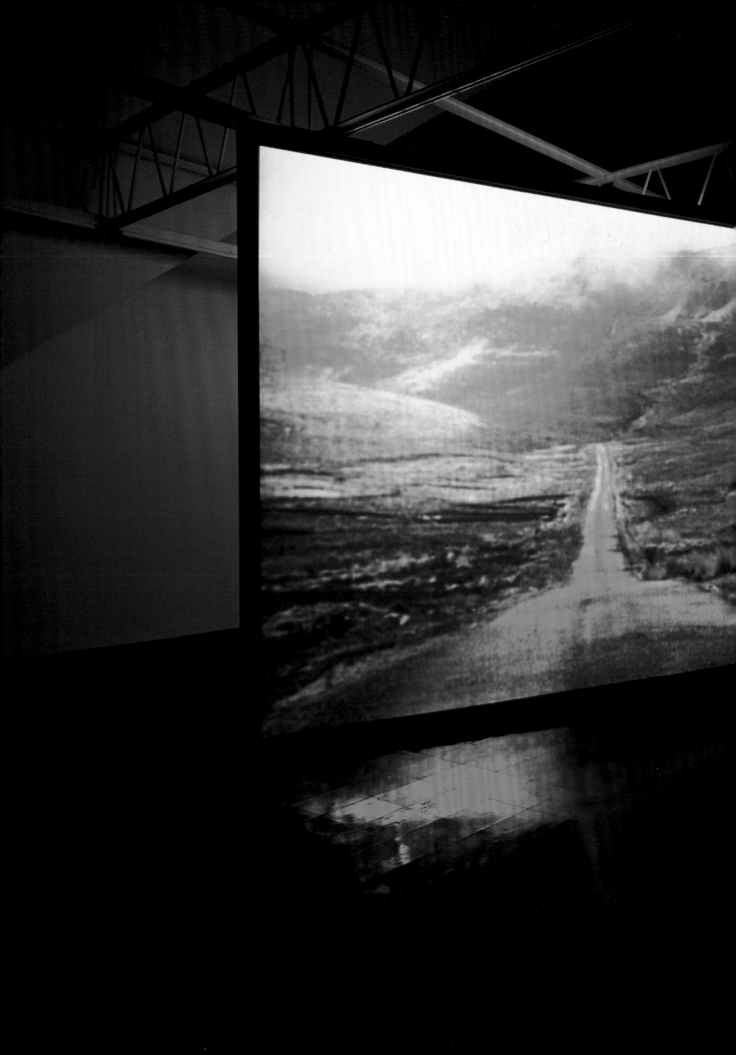

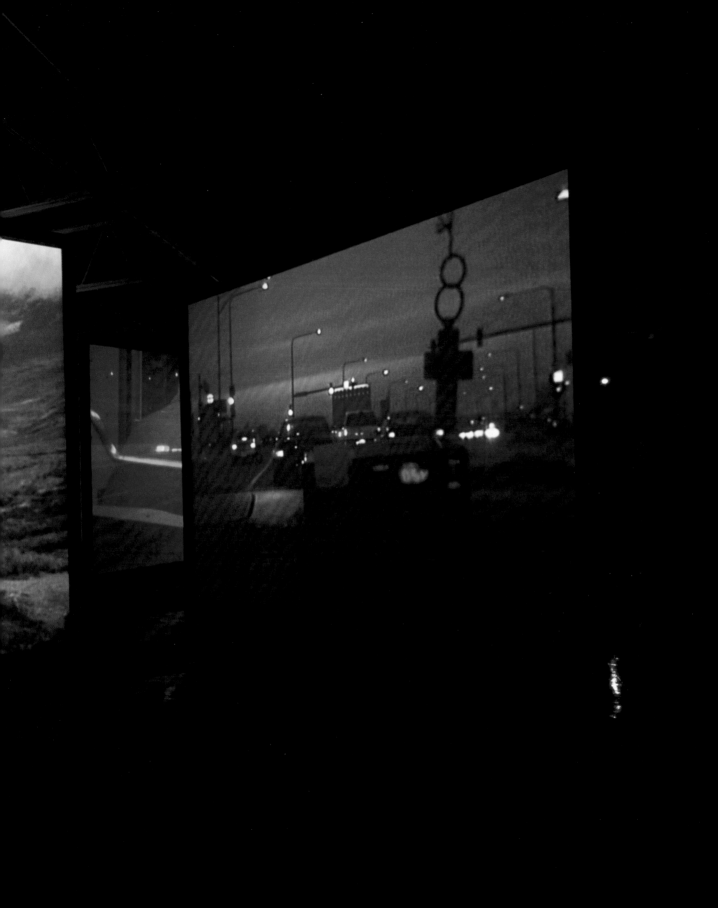

Restricted Access 1999

9 min., Farbe, Installation mit drei Monitoren (Auflage: 3)

9 minutes, color, three monitor installation (Edition of 3)

Erstaufführung First shown at Alexander and Bonin, New York

Courtesy In the collection of Afinsa, Madrid (1/3)

Restricted Access ist eine Installation mit drei Videomonitoren, die in einer waagerechten Linie an der Wand eines kleinen Raums angebracht sind. Jeder Monitor zeigt ein anderes Detail des dichten Waldes in der Nähe der Grenze zwischen Derry und Donegal. Anfangs erscheint jedes der Bilder statisch, bei näherer Betrachtung allerdings werden kleinere Veränderungen sichtbar.

Jeder Ausschnitt wurde aus einer wesentlich längeren Szene zusammengeschnitten, um so einen Zeitraffereffekt zu erzielen. Folglich wird die Echtzeit missachtet, wenn die Kamera langsam durch das Unterholz fährt oder statisch und auf dieselbe Szene fixiert bleibt. Die drei Sequenzen wechseln einander alle drei Minuten kreisförmig ab, sodass der Eindruck wechselnder Standpunkte bei einer Reihe von Überwachungsmonitoren suggeriert wird.

Restricted Access is an installation of three video monitors that are horizontally placed along a wall of a small space. Each monitor shows a different detail of a dense wood located close to the Derry–Donegal border. Initially each image appears to be static, but on closer inspection small shifts in the image are perceptible.

Each section is edited from a much longer sequence to create a time-lapse effect. Consequently, real time is collapsed as the camera pans slowly across the undergrowth or remains static, fixed on the same scene. The three sequences rotate in turn every three minutes, suggesting the shifting viewpoints of a row of surveillance monitors.

Control Zone 1999

30 min., Farbe, Installation mit Einzelprojektion (Auflage: 3)

30 minutes, color, single screen installation (Edition of 3)

Erstaufführung First shown at Koldo Mitxelena, Donostia-San Sebastián

Privatsammlung, Pamplona, Spanien (1/3)

In a private collection, Pamplona, Spain (1/3)

Bei *Control Zone* handelt es sich um eine einteilige Videoinstallation, die unmittelbar auf die Wand eines abgedunkelten Raums projiziert wird. Die Arbeit besteht aus einer in Echtzeit aufgenommenen dreißigminütigen Videosequenz. Diese wurde von einem entfernten Aussichtspunkt oberhalb der Craigavon-Brücke aufgenommen, welche in Derry das hauptsächlich von Protestanten/Loyalisten bewohnte Ostufer von dem vor allem katholischen/nationalistischen Westufer des Foyle trennt. Die Kamera befindet sich auf einer Ebene mit der Brücke, sodass die Fahrzeuge auf dieser in einer vertikalen Bewegung auf- und abwärts der Leinwand gefangen zu sein scheinen. Dieser Effekt wird zusätzlich durch die Verwendung eines starken Teleobjektivs verstärkt, durch das Entfernung und Raum scheinbar gestaucht werden.

Control Zone is a single-channel video installation projected directly onto a wall of a dark space. The work consists of a thirty-minute video sequence shot in real time. The sequence is filmed from a distant vantage point above the Craigavon Bridge, which separates the mainly Protestant/Loyalist community on the east bank from the mainly Catholic/Nationalist community on the west bank of the River Foyle, in Derry. The camera is directly in line with the bridge so that the vehicles appear locked into a vertical movement up and down the screen. The effect is enhanced by the use of a powerful telephoto lens that compresses the reading of distance and space.

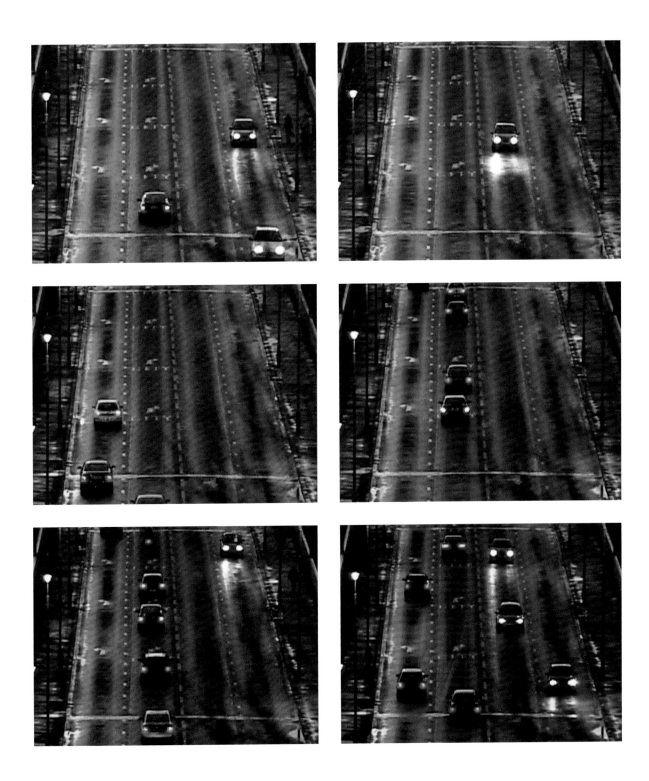

Many Have Eyes but Cannot See 2001

2 min., Farbe, Installation mit zwei Monitoren (Auflage: 3)
2 minutes, color, two monitor installation (Edition of 3)
Erstaufführung First shown at Alexander and Bonin, New York
Sammlung des Künstlers Collection of the artist

Many Have Eyes but Cannot See wurde im Jahr 2001 für eine Gruppenausstellung mit dem Titel *Self Portrait* bei Alexander and Bonin in New York produziert. Zwei Nahaufnahmen vom linken und rechten Auge des Künstlers werden auf zwei auf einer Konsole nebeneinander angebrachten Monitoren abgespielt. Die beiden Aufnahmen wurden zu verschiedenen Zeiten gedreht und bewegen sich folglich asynchron zueinander. Dabei scheinen die Augen zu versuchen, sich auf irgendeinen Gegenstand außerhalb des Bildes zu konzentrieren.

Der Titel der Arbeit ist einem Wandbild aus der Gegend um Bogside in Derry entnommen, auf dem die Medien als eine Figur mit verbundenen Augen dargestellt sind, unfähig, die von den Briten in Irland verübten Ungerechtigkeiten zu sehen.

Many Have Eyes but Cannot See was produced for a group exhibition, titled *Self Portrait*, at Alexander and Bonin, New York, in 2001. Two close-up sequences of the artist's left and right eyes are shown on two monitors, placed side by side on a shelf. The two clips of the artist's eyes are shot at different times and consequently move out of sync with each other. Both eyes appear to be straining to focus on some object outside of the frame.

The title of the work was appropriated from a wall mural in the Bogside area of Derry that depicted the media as a blindfolded figure unable to see the injustices perpetrated by the British in Ireland.

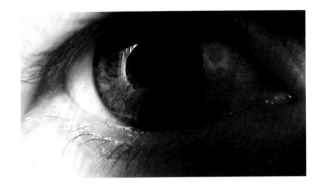 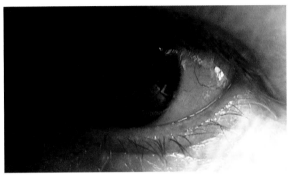

How It Was 2001

7 min., Farbe, Ton, Installation mit Doppelprojektion (Unikat)

7 minutes, color, sound, two screen installation (Unique)

Erstaufführung First shown at The Ormeau Baths Gallery, Belfast

Sammlung des Künstlers Collection of the artist

How It Was besteht aus zwei synchronisierten Videosequenzen, die auf zwei freistehende Lein-
wände projiziert werden, sodass die Bilder von beiden Seiten betrachtet werden können. Das
Filmmaterial für diese Arbeit entstand in einer ehemaligen Autoreparaturwerkstatt, die Doherty
einschließlich Werkzeugen und vorhandener Einrichtung vorgefunden hatte und für die Filmauf-
nahmen komplett unverändert beließ. In beiden Szenen treten eine Schauspielerin und zwei
männliche Schauspieler auf, wobei jeweils dieselben Szenen mit allen drei Darstellern aufge-
nommen wurden. Der Ton zum Film wird von drei Stimmen gesprochen.

Beide Videosequenzen setzen sich aus denselben aneinander gereihten Aufnahmen
zusammen, die jedoch in jeder Szene in der jeweils umgekehrten Reihenfolge gezeigt werden.
Somit bedeutet der Anfang der einen Szene das Ende der anderen, während genau nach der
Hälfte der Szene auf jeder Leinwand für einen kurzen Moment dasselbe Bild erscheint.

How It Was consists of two synchronized 16:9 video sequences, projected on to two freestand-
ing screens that allow the imagery to be viewed from both sides. The video footage was shot in
an abandoned car mechanic's garage. The garage was discovered with all the tools and fixtures
intact and was not altered in any way for the making of the video. One female and two male
actors appear in both sequences. The same scenes are shot with all three actors. A soundtrack,
featuring three voices, accompanies both sequences.

Both video sequences are composed of the same series of shots but these are shown
in reverse order in each sequence. Thus, the start of one sequence is the end of the other and
there is a point in the middle where the same image appears briefly on each screen.

Darsteller Cast Jonathan Burgess, Richard Laird, Michelle Lake

Kamera Director of Photography Vinnie Cunningham

Ton Sound Recordist Billy Gallagher

Drehbuch Script Writer Dave Duggan

Aufnahmeleitung Production Assistant Harry Burke

How It Was 2001

The light plays tricks at that time of day.

It all happened so long ago, it's like a different world.

I didn't expect to find it in the drawer, but I thought I should look. At least look.

There was no going back to check. Everything is changed.

As if everything was covered in dust.

I wasn't in any hurry. As far as I was concerned I was alone and I could take as much time as I needed.

His left hand was obscured. You couldn't see anything in the drawer.

Everything is changed.

I was there and I have doubts.

There was a TV set in the small office. I'm not sure if it was on.

But I thought I should look. At least look.

As far as I was concerned I was alone and I could take as much time as I needed.

I remember it as a gray space. As if everything was covered in dust.

There was a hammer on the wall.

By the late afternoon everything was over.

Retraces 2002

15 min., Farbe, Installation mit sieben Monitoren (Auflage: 3)
15 minutes, color, seven monitor installation (Edition of 3)
Erstaufführung First shown at Matt's Gallery, London

Bei *Retraces* handelt es sich um eine Installation mit sieben separaten, doch aufeinander bezogenen Videosequenzen. Sie werden gleichzeitig auf sieben Monitoren abgespielt, welche auf unterschiedlicher Höhe an einer Wand angebracht sind.

Das gesamte Filmmaterial wurde mit statischer Kamera ganz ohne Kippen, Schwenken, Zoomen oder Verändern der Brennweite aufgenommen. Die Aufnahmen entstanden an mehreren städtischen Schauplätzen an der Grenze zwischen Derry und Donegal. Die Arbeit wurde so geschnitten, dass während der Dauer des Films auf verschiedenen Monitoren simultan oder zeitlich versetzt Variationen derselben Einstellungen zu sehen sind. Diese können sowohl hinsichtlich ihrer Dauer wie ihres Tempos variieren, da einige von ihnen langsamer oder schneller abgespielt werden. Gewöhnlich wechselt jede Sequenz zwischen tagsüber und bei Nacht gedrehten Szenen vor städtischer und ländlicher Kulisse.

Gelegentlich wird während jeder Szene ein kurzer Text als Untertitel eingeblendet, der sich auf ein bestimmtes Datum, eine Zeit oder einen Ort bezieht. Dieses Mittel spiegelt Konventionen des fiktionalen beziehungsweise dokumentarischen Films wider, mit denen die Geschichte/der Plot zeitlich und örtlich eingebunden oder verschoben werden.

Retraces is an installation of seven separate but related video sequences shown simultaneously on seven monitors. The monitors are installed at varying heights along one wall.

All the footage is shot using a static camera that does not tilt, pan, or shift zoom or focus. The footage is shot in a number of urban locations in Derry and Belfast, and in various rural locations along the Derry–Donegal border. The work is edited so that variations of the same shots appear on different screens simultaneously and at different times throughout the duration of the work. These shots may vary in duration but also speed, as some have been slowed down or speeded up. In general, each sequence alternates between scenes shot at night or day and in urban or rural locations.

Occasionally, during each sequence a short text referring to a specific date, time, or place appears as a subtitle. This device echoes the convention used in fiction and documentary film to locate and shift the story/plot within space and time.

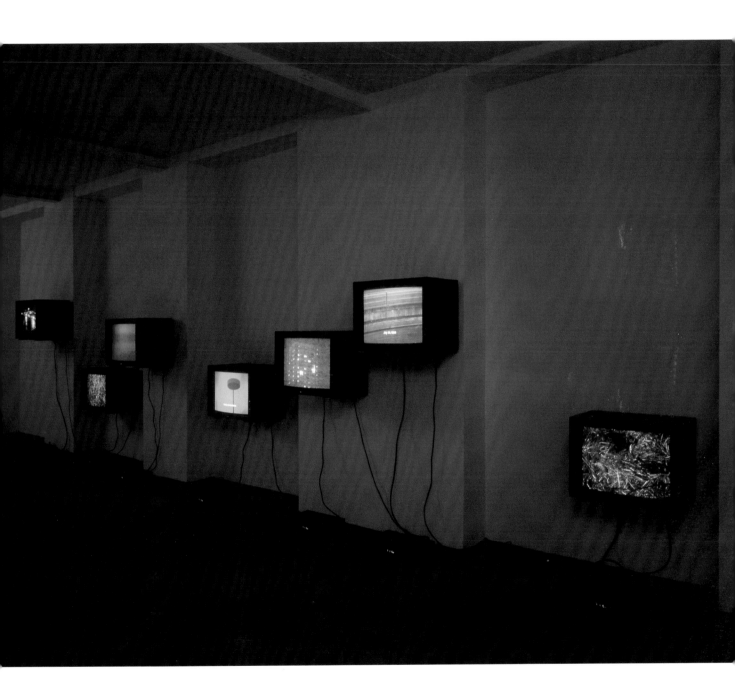

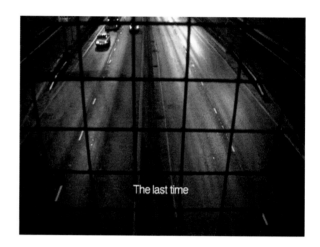

The last time

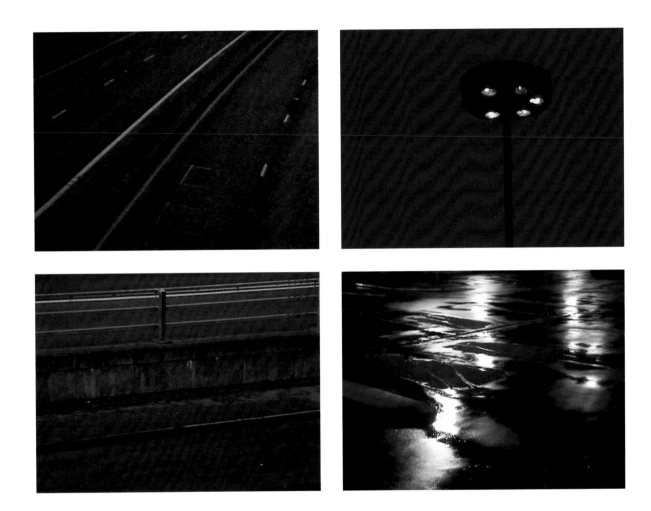

Re-Run 2002

30 sek., Farbe, Ton, Installation mit Doppelprojektion (Unikat)
30 seconds, color, sound, two screen installation (Unique)
Erstaufführung First shown at XXV Bienal de São Paulo
Courtesy In the collection of Tate, London

Re-Run besteht aus zwei kurzen Videosequenzen, die einen bei Nacht über eine Brücke ren-
nenden Mann zeigen. Beide Szenen dauern dreißig Sekunden und werden als nahtloser Loop in
einer verlängerten Sequenz gezeigt. Jede Filmsequenz setzt sich aus mehreren, mit kurzer, mitt-
lerer und hoher Brennweite gedrehten Einstellungen von ein und derselben Person zusammen,
die über eine Brücke läuft. Aus diesem Material entstand eine kurze, rasante Szene mit etwa
42 Einzelschnitten. Die laufende Figur befindet sich stets auf der Mitte der Brücke, erreicht nie
ihr eigentliches Ziel. In einer Sequenz sieht man den Mann auf die Kamera zulaufen, die sich im
selben Tempo von ihm entfernt. Eine andere Szene zeigt ihn quasi vor der Kamera davonlaufen,
während diese ihm folgt, um ihn konstant im Bild zu halten.

Re-Run consists of two short video sequences showing a male figure running across a bridge
at night. Each video sequence lasts thirty seconds and is seamlessly looped to create an
extended sequence. Each sequence is compiled from multiple takes of the same figure running
across the bridge, i.e. in wide shot, mid-shot, close-up. This material is edited to make a short,
fast sequence of approximately forty-two separate cuts. The figure is located, permanently run-
ning, in the middle of the bridge. He never reaches his destination. One sequence depicts the
man running towards the camera, which is moving away from him, at the same speed. The other
sequence shows the man running away from the camera, which is moving after him, keeping
him constantly within the frame.

Darsteller Cast Jim Norris
Produktionsleitung Producer Pearse Moore
Kamera Director of Photography Seamus McGarvey
Steadycam-Assistent Steadicam Operator Brian Drysdale
Kameraassistent Focus Puller Eric Greenberg
Oberbeleuchter Gaffer Brian Livingstone
Materialassistenz Grip Glynn Harrison
Aufnahmeleitung Production Assistants Martin Quigley, Alan Manning
Kameraausstattung und Beleuchtung Camera Equipment and Lighting Roy Harrison, Panavision Belfast
Fahrzeuge Vehicles Alan Crozier, G and H

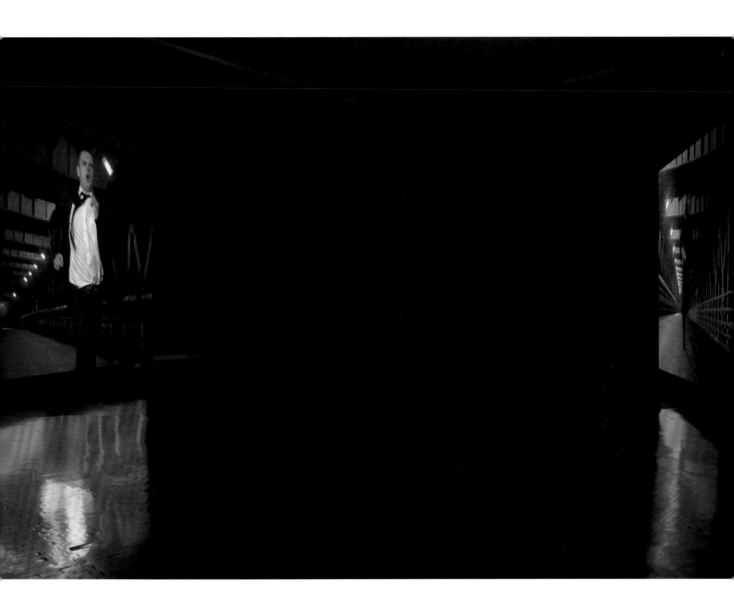

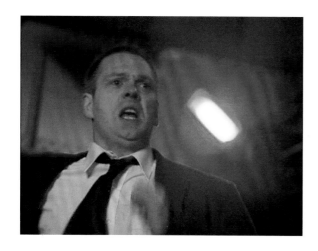

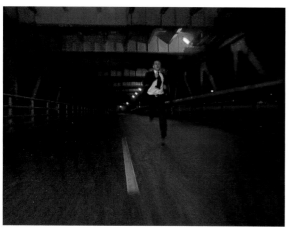

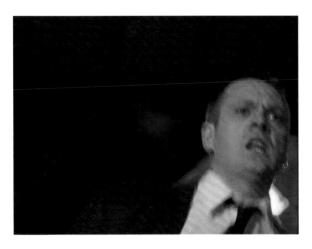

Drive 2003

30 sek., Farbe, Ton, Installation mit Doppelprojektion (Auflage: 3)
30 seconds, color, sound, two screen installation (Edition of 3)
Erstaufführung First shown at Art Unlimited, Art 34 Basel
Privatsammlung, Pamplona, Spanien (1/3)
In a private collection, Pamplona, Spain (1/3)

Drive besteht aus zwei kurzen Videosequenzen, die einen bei Nacht in einem Auto fahrenden Mann zeigen. Jedes Video dauert dreißig Sekunden und wird als nahtloser Loop zu einer längeren Szene erweitert. Die Kulisse wird von einem grünen Licht erhellt, das von roten Lichtblitzen unterbrochen wird, als das Auto unter den Lichtern der Autobahn hindurchfährt. In einer Szene steuert der Mann beiläufig das Auto, während er in einer anderen seine Hände auf das Lenkrad gelegt hat und eingeschlafen ist. Beide Szenen werden von einem kurzen wiederholten Fahrgeräusch begleitet.

Drive consists of two short video sequences showing a male figure driving a car at night. Each video lasts thirty seconds, but is seamlessly looped to create an extended sequence. The scene is lit with a green light that is interrupted by flashes of red as the car passes under the motorway lights. In one sequence the man is casually driving the car, while in the other sequence he has his hands on the steering wheel, but he is asleep. Both sequences are accompanied by the short, repetitive sound of the car driving on the road.

Darsteller Cast Stuart Graham
Produktionsleitung Producer Pearse Moore
Kamera Director of Photography Seamus McGarvey
1. Kameraassistent Focus Puller Conor Hammond
2. Kameraassistent Camera Assistant Ray Carlin
Oberbeleuchter Gaffer Brian Livingstone
Materialassistenz Grip Glynn Harrison
Lichttechnik Electrician Carlo McDonnell
Ton Sound Recordist Kwamena Daniels
Szenenbild Art Director Barbara Ann Carville
Garderobe/Maske Wardrobe/Makeup Claire Millar
Aufnahmeleitung Production Assistant Jim Norris
Kameraausstattung und Beleuchtung Camera Equipment and Lighting Roy Harrison, Panavision Belfast
Fahrzeuge Vehicles Alan Crozier, G and H

 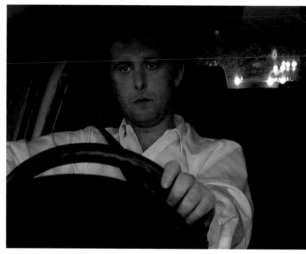

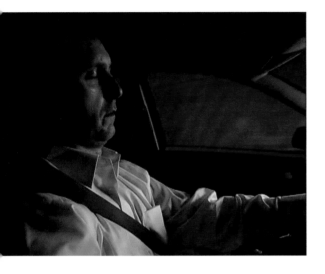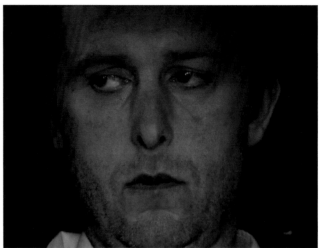

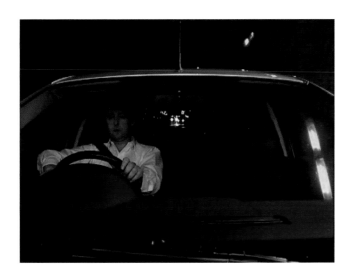 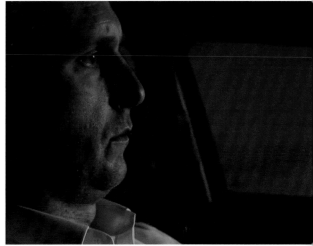

Non-Specific Threat 2004

7:46 min., Farbe, Ton, Installation mit Einzelprojektion (Auflage: 3)

7:46 minutes, color, sound, single screen installation (Edition of 3)

Erstaufführung First shown at Galerie Peter Kilchmann, Zürich Zurich

Courtesy In the collections of Sammlung Goetz, München Munich (1/3); Centro Ordóñez-Falcon de Fotografía,

Donostia-San Sebastián, Spanien Spain (2/3); The Walker Art Center, Minneapolis (3/3)

Bei *Non-Specific Threat* handelt es sich um eine einteilige, unmittelbar auf die Wand eines abgedunkelten Raums projizierte Videoinstallation. Der Film besteht aus einer langen, gemächlichen Kamerafahrt um einen jungen Mann herum, der allein in einer Art verlassener Lagerhalle steht. Während sich die Kamera um ihn dreht, sind wir dazu aufgefordert, die Beulen und Flecken auf seinem kahl geschorenen Kopf zu inspizieren und seinen sich verändernden Gesichtsausdruck zu deuten. Die Szene wird von einer distanzierten, doch bedrohlichen Off-Stimme begleitet, die einen zukünftigen Zustand drohenden Unheils beschreibt und ein gegenseitiges Wiedererkennen zwischen ihm und dem Zuschauer andeutet.

Non-Specific Threat is a single-channel video installation projected directly onto a wall of a dark space. The work consists of a long pan as the camera moves slowly around a young man who is standing alone in a derelict warehouse type space. As the camera rotates around the young man we are invited to scrutinize the bumps and marks on his shaved head, and to read the changing expressions on his face. The sequence is accompanied by a reserved but threatening voiceover that describes a future state of impending doom and fear, while implicating the viewer in an act of mutual recognition.

Darsteller Cast Colin Stewart

Sprecher Voiceover Artist Kenneth Branagh

Produktionsleitung Producer Pearse Moore

Kamera Director of Photography Seamus McGarvey

Spezialeffekte Special Effects James Doherty, Michael Lee

Kameraassistent Focus Puller Angela Conway

Oberbeleuchter Gaffer Brian Livingstone

Materialassistenz Grip Glynn Harrison

Lichttechnik Electrician Brett McCrumm

Aufnahmeleitung Production Assistant Tony Doherty

Ton Sound Recording Trident Sound Studios, London

Kameraausstattung und Beleuchtung Camera Equipment and Lighting Roy Harrison, Panavision Belfast

Zusätzliche Beleuchtung Additional Lighting Airstar UK Limited

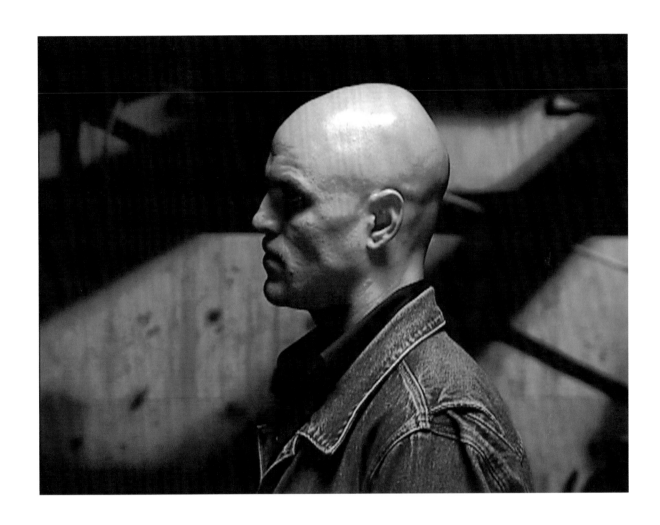

Non-Specific Threat 2004

I will make your dreams come true.
I am everywhere.
There will be no shopping
I am any color you want me to be.
I am any religion you want me to be.
I am the embodiment of everything you
despise.
There will be no television.
I am the reflection of all your fears.
I am fictional.
I am real.
There will be no radio.
I am mythical.
I am inside you.
There will be no telephones.
You think you know me.
I am unknowable.
I live alongside you.
There will be no books.
We are mutually dependent.
I need you.
There will be no water.
I am beyond reason.
I have contaminated you.
I am part of your life.
There will be no electricity.
I respond to everything you do and say.
There will be no newspapers.
I am a caricature.
There will be no magazines.
I will be anything you want me to be.

You create me.
There will be no computers.
I am everything that you desire.
I am forbidden.
There will be no e-mail.
I am your invention.
You make me feel real.
There will be no flights.
You are my religion.
We control each other.
There will be no traffic.
I am your annihilation.
Your death is my salvation.
There will be no oil.
I am the face of evil.
I am self-contained.
There will be no transport.
You manipulate me.
I am your victim.
You are my victim.
There will be no music.
I am part of your memories.
I remind you of someone you know.
I am invisible.
I disappear in a crowd.
There will be no cinema.
You can be like me.
I share your fears.
I know your desires.
There will be no art.

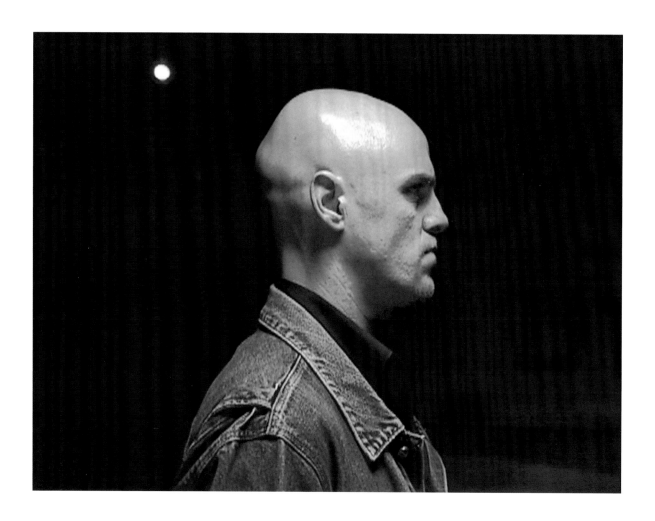

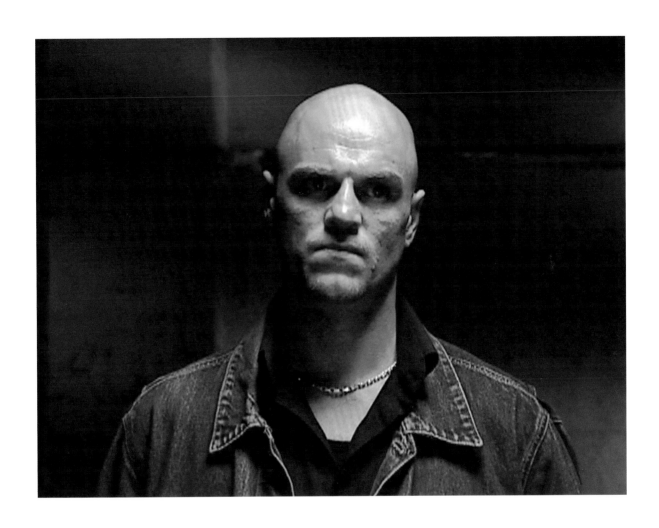

Closure 2005

11:20 min., Farbe, Ton, Installation mit Einzelprojektion (Auflage: 3)
11:20 minutes, color, sound, single screen installation (Edition of 3)
Erstaufführung First shown at Galería Pepe Cobo, Madrid
Privatsammlungen in Madrid (1/3) und Amsterdam (2/3)
In private collections in Madrid (1/3) and Amsterdam (2/3)

Bei *Closure* handelt es sich um eine einteilige, unmittelbar auf die Wand eines abgedunkelten Raums projizierte Videoinstallation. Der Film zeigt eine schwarz gekleidete junge Frau, die um die Einfassung eines langen und schmalen Platzes herumgeht. Die Kamera verfolgt die Frau, während sie die Fläche entlangschreitet, und hält sie im Bild, während gelegentlich ein Schnitt zu einer Großaufnahme ihres Gesichts erfolgt. Die Szene wird von einer Off-Stimme begleitet, die zwischen Verweisen auf die Zerstörung eines häuslichen Raums und einer Erwähnung der Entschlossenheit und Bestimmtheit der Frau angesichts offensichtlichen Elends wechselt.

Closure is a single-channel video installation projected directly onto a wall of a dark space. It shows a young woman dressed in black, walking around the perimeter of long and narrow enclosed space. The camera tracks the woman as she paces the length of the space, holding her in frame and occasionally cutting to a close-up of her face. The sequence is accompanied by a voiceover that oscillates between references to the destruction of a domestic space and an expression of the woman's determination and resolve in the face of apparent adversity.

Darsteller Cast Kathryn Brolly
Sprecherin Voiceover Artist Marie Louise Muir
Produktionsleitung Producer Pearse Moore
Kamera Director of Photography Conor Hammond
1. Kameraassistent Focus Puller Ray Carlin
2. Kameraassistent Camera Assistant Alan Manning
Oberbeleuchter Gaffer Davy Bates
Materialassistenz Grip Glynn Harrison
Aufnahmeleitung Production Assistant Tony Melarkey, Gerry Tracey, Brian Fisher
Maske Makeup Artist Claire Millar
Kameraausstattung und Beleuchtung Camera Equipment and Lighting Roy Harrison, Panavision Belfast
Filmlabor Film Lab Soho Images
Ton Sound Recording BBC, Belfast
Postproduktion Post Production Facility The Picturehouse, Belfast

Closure 2005

My purpose is clear.
My endurance is constant.

The crack is splitting.
The glass is shattered.

My mission is unending.
My anger is undiminished.

The street is ablaze.
The steel is twisted.
The surface is melting.

My ardor is fervent.
My passion is unbowed.

The roof is decomposing.
The ceiling is dripping.
The floor is submerged.

My intuition is fatal.
My judgment is decisive.

The door is permeable.
The wall is penetrated.

My faith is undimmed.
My loyalty is unwavering.

The edge is blurred.
The boundary is invisible.

My nature is ingrained.

The paint is blistering.
The veneer is peeling.
The laminate is corrupted.

My devotion is unfailing.
My will is unbending.
My submission is absolute.

The sewer is leaking.
The bed is putrid.

My intention is precise.
My choice is ruthless.

The membrane is weeping.
The plastic is mutating.
The skin is alien.

My desire is overwhelming.
My compulsion is shameful.

The joint is fragmenting.
The corner is unstable.
The cavity is airless.

My destiny is preordained.
My integrity is uncompromised.

The water is stagnant.
The seam is damp.

Passage 2006

7:52 min., Farbe, Ton, Installation mit Einzelprojektion (Auflage: 3)
7:52 minutes, color, sound, single screen installation (Edition of 3)
Erstaufführung First shown at Laboratorio Arte Alameda, Mexico City

Bei *Passage* handelt es sich um eine einteilige, unmittelbar auf die Wand eines abgedunkelten Raums projizierte Videoinstallation. Die Aufnahmen zeigen die nächtliche Ödnis neben einer Autobahn, die im Hintergrund zu hören ist. Zwei junge Männer gehen, aus entgegengesetzter Richtung kommend, aufeinander zu. Die Szene besteht aus einer Reihe von Gegenschnitten von einer Figur zur anderen. Die Männer scheinen nichts voneinander zu wissen, bis sie sich schließlich in einer kurzen Unterführung begegnen. Im Vorübergehen sieht jeder dem anderen über die Schulter nach. Es folgen Variationen dieser ersten Szene: Jede Person geht weiter, bis sie zwangsläufig immer wieder auf die andere trifft.

Passage is a single-channel video installation that is projected directly onto a wall of a dark space. The footage is shot at night in the waste ground near a motorway that is audible in the background. Two young men walk towards each other from opposite directions. The sequence is made up of a series cuts that move from one figure to the other. The men appear to be unaware of each other until they reach a point where they meet in a short underpass. As they pass, each man looks back over his shoulder at the other and continues to walk. Variations of this first sequence follow as the two figures walk away until they inevitably meet again and again.

Darsteller Cast Michael Liebmann, Ciaran McMenamin
Produktionsleitung Producer Pearse Moore
Kamera Director of Photography Conor Hammond
1. Kameraassistent Focus Puller Eric Greenberg
2. Kameraassistent Camera Assistant Alan Manning
Steadycam-Assistent Steadicam Operator Brian Drysdale
Oberbeleuchter Gaffer Davy Bates
Ton Sound Recordist Gerry Tracey
Maske Makeup Artist Liz Boston
Aufnahmeleitung Production Assistant Jamie Jackson
Kameraausstattung Camera Equipment Visual Impact
Beleuchtung Lighting Equipment Roy Harrison, Panavision Belfast
Postproduktion Post Production Facility The Picturehouse, Belfast

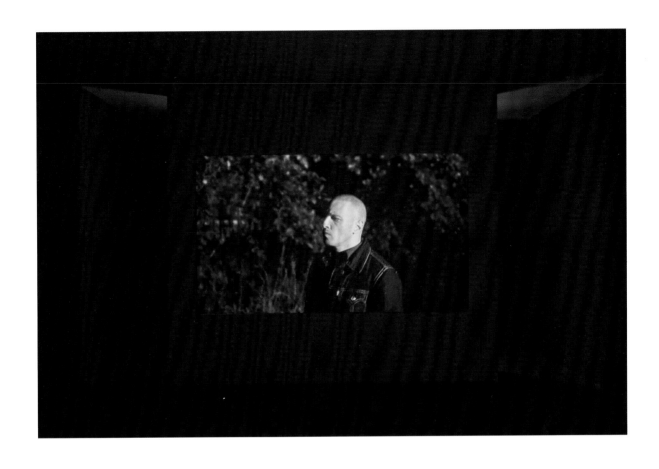

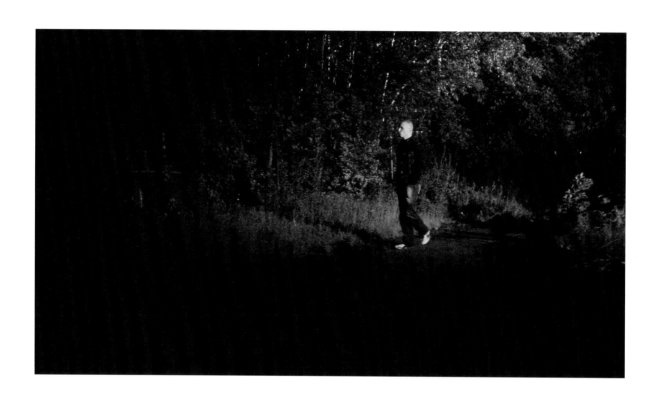

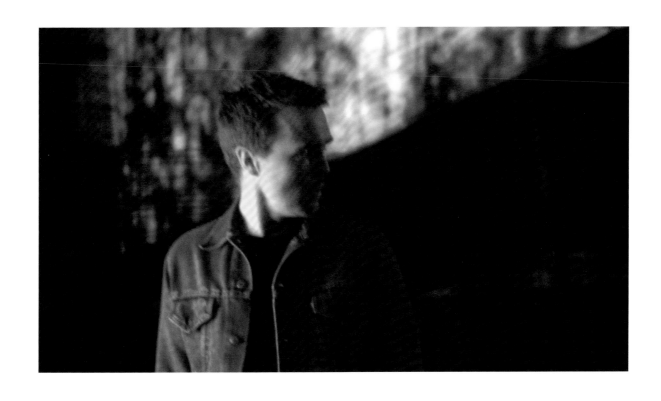

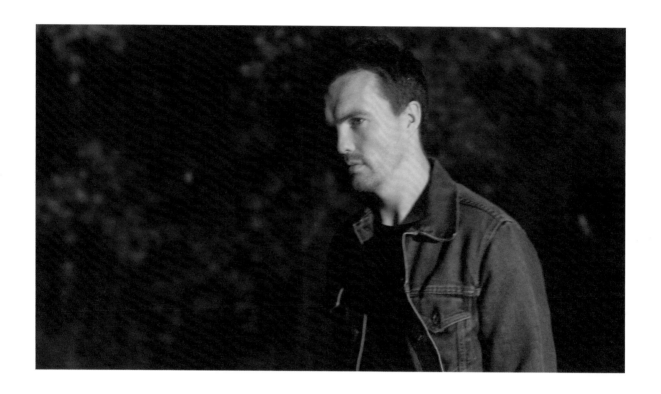

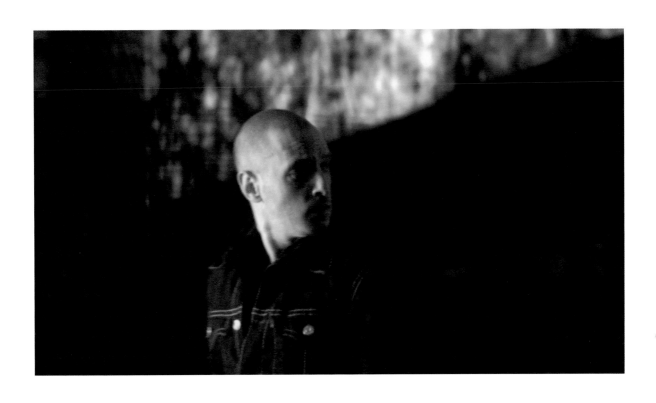

Empty 2006

8 min., Farbe, Ton, Installation mit Einzelprojektion (Auflage: 3)

8 minutes, color, sound, single screen installation (Edition of 3)

Erstaufführung First shown at Kerlin Gallery, Dublin

Courtesy In the collections of The Irish Museum of Modern Art, Dublin (1/3);

Privatsammlung Private collection, Rydal, Pennsylvania (3/3)

Bei *Empty* handelt es sich um eine einteilige, auf die Wand eines abgedunkelten Raums projizierte Videoinstallation. Das Filmmaterial entstand im Lauf eines Tages in Belfast und zeigt das Äußere eines leer stehenden Bürogebäudes. Die Szene besteht aus statischen Einstellungen, die die sich langsam verändernden Wetterbedingungen – von Wind und Regen bis hin zu strahlendem Sonnenschein – festhalten. Die Kamera inspiziert die Oberfläche des verlassenen Baus und enthüllt dabei abblätternde Farbe, rostige Fenstergitter und verwitterte Strukturen. Anschließend zeigt sie die sich wandelnden Lichtnuancen beim Vorüberziehen der Wolken an den verspiegelten Fenstern und den matt zerfurchten Verblendungen des Gebäudes. Die Szene wird begleitet von dem leise auf- und abschwellenden Hintergrundrauschen von Wind und Regen, dem Dröhnen des Verkehrs und dem Geräusch eines entfernten Hubschraubers.

Empty is a single-channel video installation projected directly onto a wall of a dark space. The footage was shot over the course of a single day on location in Belfast and records the exterior of a disused office building. The work is made up of a sequence of static shots that chart the slowly shifting weather conditions from wind and rain to bright sunshine. The surface of the abandoned building is explored, revealing its peeling paint, its rusting window grills, and its weathered textures. The camera picks up on nuances of light as clouds move across the reflective windows and the dull corrugated panels of the edifice. A low background drone that fades in and out of the ambient sounds of wind and rain, the rumble of traffic, and the sound of a distant helicopter accompany the sequence.

Produktionsleitung Producer Pearse Moore

Kamera Director of Photography Conor Hammond

Kameraassistenz Camera Assistant Noah Eli Davis

Aufnahmeleitung Production Assistant Tony Doherty

Ton Sound Recordist Gerry Tracey

Kameraausstattung Camera Equipment Conor Hammond

Zusätzliche Kameraausstattung Additional Camera Equipment Roy Harrison, Panavision Belfast

Filmlabor Film Lab Soho Images

Postproduktion Post Production Facility The Picturehouse, Belfast

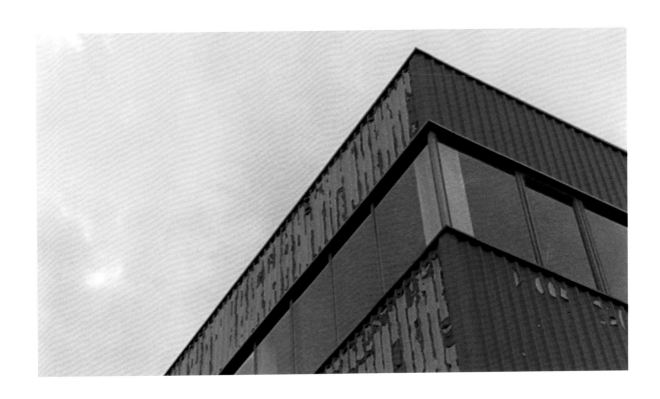

Ghost Story 2007

15 min., Farbe, Ton, Installation mit Einzelprojektion (Auflage: 3)

15 minutes, color, sound, single screen installation (Edition of 3)

Erstaufführung auf der 52. Biennale in Venedig 2007, Nordirischer Pavillon

First shown at 52nd Venice Biennale 2007, Northern Ireland Pavilion

Bei *Ghost Story* handelt es sich um eine einteilige, unmittelbar auf die Wand eines abgedunkelten Raums projizierte Videoinstallation. Die Arbeit beginnt mit der Aufnahme einer von Bäumen gesäumten Landstraße. Die Kamera fährt gemächlich den Weg entlang auf den fernen Horizont zu. Diese Einstellung wird von einer Off-Stimme begleitet, die über eine Reihe von Menschen und vergangene Ereignisse spricht. Während sich die Geschichte entspinnt, wird die ausgedehnte Kamerafahrt immer wieder durch die Aufnahme eines anderen Schauplatzes unterbrochen. Derweil weckt die Erzählung Erinnerungen an die Toten, und es entsteht eine Atmosphäre des Verlustes und böser Vorahnungen, durch welche die spukhafte Anwesenheit jener Menschen greifbar wird.

Ghost Story is a single channel video installation projected directly onto a wall of a dark space. The work opens with a shot of a country path flanked by trees. The camera moves slowly down the path toward the distant horizon. This shot is accompanied by a voiceover that refers to a series of people and past events. Occasionally this extended shot is interrupted and the scene switches to another location as the story unfolds. The narrative evokes memories of the dead and a sense of loss and foreboding, as their haunting presence is made palpable.

Darsteller Cast Matt McArdle, Jenny Leigh Wallace

Sprecher Voiceover Artist Stephen Rea

Produktionsleitung Producer Pearse Moore

Kamera Director of Photography Seamus McGarvey

Kameraassistent Focus Puller Conor Hammond

Kameraassistent Camera Assistant Andy Gardner

Steadycam-Assistant Steadicam Operator Brian Drysdale

Oberbeleuchter Gaffer Davy Bates

Materialassistenz Grip Ian Buckley

Lichttechnik Electricians Carlo McDonnell, David Mains

Maske Makeup Artist Liz Boston

Tonaufnahmen Sound Recordist Gerry Tracey, Screen Scene, Dublin

Aufnahmeleitung Production Assistant Keith O'Grady

Beleuchtung, Kameraausstattung Lighting, Camera Equipment Roy Harrison, Panavision UK, Visual Impact

Ghost Story 2007

I found myself walking along a deserted path.
Through the trees on one side I could faintly make out a river in the distance.
On the other side I could hear the faint rumble of far away traffic.
The scene was unfamiliar to me.

I looked over my shoulder and saw that the trees behind me were filled with shadow-like figures.
Looks of terror and bewilderment filled their eyes and they silently screamed, as if already aware of their fate.
The scene reminded me of the faces in a running crowd that I had once seen on a bright but cold January afternoon.
Men and women slipped on icy puddles as they ran for safety.
A few, in their panic, ran towards a wire fence, further trapping themselves.
As they scaled the fence a military vehicle drove through it tossing them into the frosty air.
Troops spewed from the back of the vehicle as it screeched to a sudden halt.
They raised their rifles and fired indiscriminately into the fleeing crowd.

The next day I walked over the waste ground that was now marked by deep tire tracks and footprints,
fixed in low relief and highlighted by a sharp hoar frost.
I could find no other traces of the crowd.
I returned many times to the same site until another fence was erected and a new building
was put in place of the empty, silent reminder.
I wondered about what had happened to the pain and terror that had taken place there.
Had it been absorbed or filtered into the ground or was it possible for others to sense it as I did?

The narrow streets and alleyways that I walked along became places where this invisible matter
could no longer be contained.
It seeped out through every crack and fissure in the worn pavements and crumbling walls.
Its substance became visible to me in the mossy, damp corners that never seemed to dry out
in winter or summer.
A viscous secretion oozed from the hidden depths.
The smell of ancient mould mingled with the creeping odor of dead flesh.
The ground was often slippery under foot as if the surface of the road was no longer thick enough to conceal
the contents of the tomb that lay beneath the whole city.

Some people claim that they are a malevolent presence while others believe that they offer guidance and advice
to their family and friends.

Not everyone can see them.
They inhabit a world somewhere between here and the next.
They move between the trees.
Caressing every branch.
Breathing, day and night, on every flickering leaf.
They are restless creatures whose intentions are often beyond our comprehension.

His body was discovered on an overcast Sunday morning.
I recognized him from the small black and white newspaper photograph that had accompanied the story
of his murder.

He smiled reluctantly, self-conscious and timid when confronted by the lens.
As a boy, I stared at this photograph looking for a sign; unable to accept that the face was that of someone already dead.

I retraced my footsteps along paths and streets that I thought I had forgotten.
I walked past the place that I used to avoid and quickened my pace.
He was waiting for me, as I always feared he would, emerging from a scorched corner where broken glass sparkled on the blackened ground.

My train of thought was interrupted by a further incursion of unreality.
My eyes deceived me as I thought I saw a human figure.
No matter how quickly or slowly I walked the figure did not seem to get any closer.
When I took my eye off the figure it disappeared.
When I stared at the point where the path vanished the figure emerged once again from the trees or from the path itself.
I could not tell.

I remembered shapes and colors from a flickering television screen.
The outline of a car silhouetted against a gray sky.
One door wide open and the car skewed awkwardly into a shallow ditch.
A detail of the interior, gray checked fabric, an oily stain, a cassette player.
The number plate, three letters and four numbers.
The car had been abandoned and was partly burned after a failed attempt to eliminate any forensic secrets that it might yield.

At first, I didn't see or hear the car.
It seemed to appear from nowhere.
In the evening twilight it was difficult to make out who was driving.
The car slowed down and waited for me to approach.

I became lost in memories of the minute details of photographs of people and places that I did not know.
Men being taken away blindfolded.
Their hands tightly bound by plastic cable ties.
Barking dogs. Cages.
Bodies in a pile. Guards standing over them smiling for the camera.
Stains on a white floor.
A car blown apart in a surgical strike.
A shoe and a newspaper lying on the dusty road.
A dazed family huddled in a bright sunlit street.
Their clothes and faces splattered with blood that seemed to match the mosaic pattern on the wall behind them.

The daylight wraith takes on the likeness of a living person.
The wraith is usually a vision of someone who is in another place at the time of the appearance.
It manifests itself during the hours of daylight in a place where the living person could not possibly be.
A wraith can assume the likeness of a close friend or relative or even appear as the viewer's own image.
The appearance of a friend or relative usually means that the person is already dead or in great danger.
To see one's own image is a warning of one's death within a year.

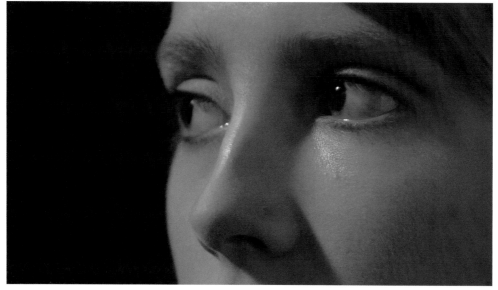

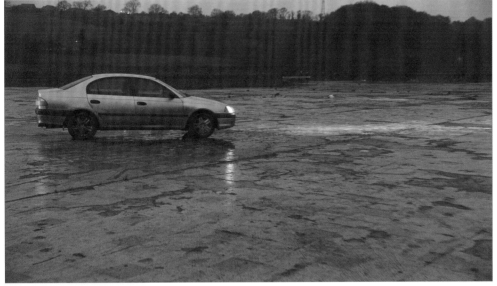

Willie Doherty

1959	geboren born in Derry, Northern Ireland
1978–1981	Ulster Polytechnic, Belfast
	Lebt und arbeitet Lives and works in Derry.

Preise und Stipendien Awards and Residencies

1995	Irish Museum of Modern Art,
	Glen Dimplex Artists Award
1999	DAAD Stipendium DAAD Grant, Berlin

Einzelausstellungen (Auswahl ab 1998)
Selected Solo Exhibitions since 1998

2007	*Willie Doherty. Stories*, Städtische Galerie im
	Lenbachhaus und Kunstbau, München Munich
	Willie Doherty, Kunstverein in Hamburg
	Nordirischer Pavillon, 52. Biennale Venedig
	Northern Ireland Pavilion, 52nd Venice Biennale
	Passage, Alexander and Bonin, New York
2006	*Empty*, Galerie Peter Kilchmann, Zürich Zurich;
	Kerlin Gallery, Dublin
	Out of Position, Laboratorio Arte Alameda,
	Mexico City
2005	*Apparatus*, Galería Pepe Cobo, Madrid
	Willie Doherty, Museum of Contemporary Art,
	Belgrad Belgrade
2004	*Non-Specific Threat*, Alexander and Bonin,
	New York; Galerie Peter Kilchmann, Zürich Zurich
2003	*Willie Doherty*, De Appel Foundation, Amsterdam
2002	*False Memory*, Irish Museum of Modern Art, Dublin
	Unknown Male Subject, Kerlin Gallery, Dublin
	Retraces, Matt's Gallery, London
2001	*How It Was/Double Take*, Ormeau Baths Gallery,
	Belfast
	Extracts From a File, Alexander and Bonin, New York
2000	*Extracts From a File*, Galerie Peter Kilchmann,
	Zürich Zurich; daadgalerie, Berlin; Gesellschaft
	für Aktuelle Kunst, Bremen

	Extracts From a File, Kerlin Gallery, Dublin
1999	*Dark Stains*, Koldo Mitxelena Kulturunea,
	San Sebastián, Spanien Spain
	Willie Doherty – New Photographs and Video,
	Alexander and Bonin, New York
	Same Old Story, First Site, Colchester, England
	Somewhere Else, Museum of Modern Art, Oxford
	True Nature, The Renaissance Society, Chicago
1998	Galerie Jennifer Flay, Paris

Gruppenausstellungen (Auswahl ab 1998)
Selected Group Exhibitions since 1998

2007	*Going Staying*, Kunstmuseum Bonn
	Speed 3, IVAM, Valencia
	Turbulence, 3. Auckland Triennale 3rd
	Auckland Triennial, Auckland, Neuseeland
	New Zealand
2006	*Re: Location*, Alexander and Bonin, New York
	Reprocessing Reality, P.S.1 Contemporary Art
	Center, Long Island City, New York
	Image War: Contesting Images of Political Conflict,
	Whitney Museum Independent Study Program,
	The Art Gallery of The Graduate Center, CUNY,
	The City University of New York
	ARS 06, Kiasma Museum of Contemporary Art,
	Helsinki
2005	*The Experience of Art*, Italienischer Pavillon,
	51. Biennale Venedig Italian Pavilion, 51st Venice
	Biennale
	The Shadow, Vestsjaellands Kunstmuseum, Sorø,
	Dänemark Denmark
	Non-Stop, Kunstverein Wolfsburg, Wolfsburg
	Reprocessing Reality, Château de Nyon, Nyon,
	Schweiz Switzerland
	Faces in the Crowd, Castello di Rivoli, Museo
	d'Arte Contemporanea, Turin
	Format 05, Q Gallery, Derby
	Slideshow, Baltimore Museum of Art
2004	*Faces in the Crowd: The Modern Figure and
	Avant-Garde Realism*, Whitechapel Gallery, London
	Dwellen, Charlottenburg Exhibition Hall,
	Kopenhagen Copenhagen

Clocal: Apuntes para Videopresentaciones de lo global y lo local, Galería Moisés de Albéniz, Pamplona, Spanien Spain

Recherche entdeckt!, 6. Internationale Foto-Triennale 6th International Photo Triennial, Esslingen

Dritte Berlin Biennale für Zeitgenössische Kunst, Berlin 3rd Berlin Biennial for Contemporary Art

2003 *Cambio de Valores*, Espai d'Art Contemporani de Castelló, Castelló de la Plana/Castellón, Spanien Spain

Turner Prize 2003, Tate Gallery, London

Moving Pictures, Guggenheim Museum Bilbao

Poetic Justice, 8. Internationale Biennale Istanbul 8th International Istanbul Biennial

Site Specific, Museum of Contemporary Art, Chicago

Imperfect Mariages, Galleria Emi Fontana, Mailand Milan

Art Unlimited, Art 34 Basel, Die Internationale Kunstmesse The International Art Fair

Re-Run, Städtische Kunsthalle, Mannheim

2002 *Retraces*, Alexander and Bonin, New York

The Gap Show, Museum am Ostwall, Dortmund

formal social, Westfälischer Kunstverein, Münster Munster

Re-Run, 25. Biennale São Paulo 25th São Paulo Biennial

2001 *Das Innere Befinden: Das Bild des Menschen in der Videokunst der 90er Jahre* The Inner State, The Image of Man In the Video Art of the 1990s, Kunstmuseum Liechtenstein, Vaduz

Trauma, Dundee Contemporary Arts, Dundee, Schottland Scotland

The Uncertain, Galería Pepe Cobo, Sevilla

Bloody Sunday, Orchard Gallery, Derry

Double Vision, Galerie für Zeitgenössische Kunst, Leipzig

Gisela Bullacher / Willie Doherty, Produzentengalerie, Hamburg

2000 *Drive: power > progress > desire*, Govett-Brewster Art Gallery, New Plymouth, Neuseeland New Zealand

Galerie Peter Kilchmann, Zürich Zurich

1999 *Carnegie International*, Carnegie Museum of Art, Pittsburgh

Expansive Vision: Recent Acquisitions of Photographs in the Dallas Museum of Art, Dallas

Irish Art Now: From the Poetic to the Political, McMullen Museum of Art, Boston College; Art Gallery of Newfoundland and Labrador, Canada; Chicago Cultural Center

Endzeit – Fotografien und Videoarbeiten, Galerie Six Friedrich Lisa Ungar, München Munich

Insight-Out, Kunstraum Innsbruck; Kunsthaus Hamburg; Kunsthaus Baselland, Muttenz / Basel

Nouvelles acquisitions 97, Collège Trois Fontaines, Reims

Photographs, Alexander and Bonin, New York

Junge britische und amerikanische Kunst aus der Sammlung Goetz, Deichtorhallen Hamburg

1998 *New Art From Britain*, Kunstraum Innsbruck

Fuori Uso '98, Mercati Ortofrutticoli, Pescara

Critical Distance: Michael Danner, Willie Doherty, Sophy Rickett, Andrew Mummery Gallery, London

Photography as Concept, 4. Internationale Foto-Triennale 4th International Photo Triennial, Esslingen

Art from the UK (Part II), Sammlung Goetz, München Munich

Wounds: Between Democracy and Redemption in Contemporary Art, Moderna Museet, Stockholm

Real / Life: New British Art, Tochigi Prefectural Museum of Fine Arts, Fukuoka City; Art Museum, Hiroshima City; Museum of Contemporary Art, Tokyo

A Sense of Place, Angles Gallery, Los Angeles

Film Television

1985 *Picturing Derry*, Faction Films für for Channel 4, Dezember December

Projekte im öffentlichen Raum Public Projects

1995 *Make Believe*, Posterprojekt für Bahnhöfe
 der British Rail Poster project for British Rail
 mainline stations
 The Space Between, Videoinstallation Video
 installation, El Puente de Vizcaya, Bilbao

1994 Installation, Washington Square Windows,
 Grey Art Gallery, New York University

1993 *Burnt-Out Car, Street Poster, An Irish Presence*,
 45. Biennale Venedig 45th Venice Biennale
 A Nation Once Again, Straßenposter im Auftrag
 der Transmission Gallery Glasgow im Rahmen
 der Ausstellung *Outta Here* Street Poster
 commissioned by Transmission Gallery, Glasgow,
 as part of *Outta Here*
 It's Written All Over My Face, Auftrag des BBC-
 Billboard Project Billboard Poster commissioned
 by BBC Billboard Project

1990 *False Dawn*, Plakatprojekt der *Irish Exhibition
 of Living Art*, Dublin Billboard project organized
 by *Irish Exhibition of Living Art*, Dublin
 Metro Billboard Project, Projects UK, Plakatwand
 Billboard Newcastle, Leeds, Manchester, Derry,
 London

1988 *Art For The Dart*, Projekt über Dublins Vorort-
 schienennetz, organisiert von der A project on
 Dublin's suburban rail link, organized by
 Douglas Hyde Gallery, Dublin

Bibliografie Bibliography

Ausstellungskataloge (Einzelausstellungen, Auswahl)
Selected exhibition catalogues

2006 *Willie Doherty: Out of Position*, Laboratorio Arte
 Alameda, Mexico City

2002 Charles Merewether, *Willie Doherty, Re-Run*,
 25. Biennale São Paulo 25th São Paulo Biennial

2001 *Willie Doherty: False Memory*, Irish Museum of
 Modern Art, Dublin

1999 Maite Lorés, Martin McLoone, *Willie Doherty: Dark
 Stains*, Koldo Mitxelena Kulturunea, San Sebastián

1998 *Willie Doherty: Extracts From a File*, daadgalerie,
 Berlin; Gesellschaft für Aktuelle Kunst, Bremen

1997 Martin Mc Loone, Jeffrey Kastner, *Willie Doherty:
 Same Old Story*, Matt's Gallery, London

1996 Carolyn Christov-Bakargiev, *Willie Doherty: In the
 Dark. Projected Works*, Kunsthalle Bern, Bern Berne
 Jean Fisher, *Willie Doherty: The Only Good One Is
 a Dead One*, The Edmonton Art Gallery; Mendel
 Art Gallery, Edmonton
 Olivier Zahm, *Willie Doherty*, Musée d'Art Moderne
 de la Ville de Paris, Paris

1993 *No Smoke Without Fire*, 25 Farbtafeln und Aus-
 schnitte aus Videoinstallationen und Soundtracks
 25 colorplates and excerpts from video installation
 soundtracks, Matt's Gallery, London
 Dan Cameron, *Patial View. Work of Willie Doherty*,
 The Douglas Hyde Gallery, Dublin; Grey Art Gallery,
 New York; Matt's Gallery, London

Ausstellungskataloge (Gruppenausstellungen, Auswahl)
Selected exhibition catalogues of group shows

2006 Tuula Karjalainen, Jari-Pekka Vanhala, *ARS 06 /
 Sense of the Real*, Museum of Contemporary Art
 Kiasma, Helsinki, S. 29–30, 111–112 pp. 29–30,
 111–12.

2005 Jean Fisher, *Belonging: Sharjah Biennial 7 / where
 here is elsewhere*, Sharjah Art Museum, Vereinigte
 Arabische Emirate United Arab Emirates
 Justin Hoffman, *Non-Stop*, Kunstverein Wolfsburg,
 Wolfsburg, S. 5–9, 38f., 82 pp. 5–9, 38–39, 82.
 Christine Buhl Andersen, *The Shadow*,
 Vestsjaellands Kunstmuseum, Sorø, Dänemark
 Denmark, S. 44–47 pp. 44–47.
 Tacita Dean, Jeremy Millar, *Place*, London, S. 116f.,
 195 pp. 116–17, 195.
 Claudia Spinelli, *Reprocessing Reality*, Château de
 Nyon, Nyon, S. 90–96, 204 pp. 90–96, 204.

2004 Friederike Klapp, Willie Doherty, in: *3. Berlin
 Biennale für Zeitgenössische Kunst*, Berlin, S. 64f.,
 178 pp. 64–65, 178.

2003 Luis Francisco Perez et al., *Cambio De Valores /
 The Rings of Saturn*, Fundación ARCO, Madrid;
 Centro Galego de Arte Contemporánea (CGAC),
 Santiago de Compostela, S. 44f., 171, 182–193
 pp. 44f., 171, 182–93.
 Ben Tufnell, *Turner Prize 2003*, Tate Britain,
 London, S. 2, 3f., 13 pp. 2, 3–4, 13.

2001 Carina Plath, *The Gap Show, Junge Zeitkritische Kunst aus Großbritannien*, Museum am Ostwall, Dortmund, S. 52–59 pp. 52–59.
 formal social, Westfälischer Kunstverein, Münster Munster

2000 *Das Innere Befinden: Das Bild des Menschen in der Videokunst der 90er Jahre* The Inner State, The Image of Man In the Video Art of the 1990s, Kunstmuseum Liechtenstein, Vaduz
 Double Vision, Galerie für Zeitgenössische Kunst, Leipzig
 Michael Rush, *New Media in Late 20th Century Art*, London
 Insight Out, Kunstraum Innsbruck

1998 *Somewhere Else*, Tate Gallery, Liverpool
 Ingvild Goetz, Christiane Meyer-Stoll, *Art from the UK*, Sammlung Goetz, München Munich, S. 40–47 pp. 40–47.

Zeitschriftenartikel (Auswahl)

Selected Reviews and Articles

2007 Michael Wilson, Willie Doherty. Alexander and Bonin, in: *Artforum International*, März, S. 314 March, p. 314.

2006 Daniel Völzke, Wuchernde Welt: Der irische Künstler Willy [sic!] Doherty zeigt neue Video- und Fotoarbeiten in der Galerie Nordenhake, in: *Tagesspiegel*, 14. Jan. Jan. 14.

2005 Chrissie Iles, Venice Biennial 2005, in: *Frieze*, Nr. 93, Sept., S. 98–100 No. 93, Sept., pp. 98–100.
 Maeve Conolly, In Conversation: Experience and Alterity at the 51st Venice Biennale, in: *Contemporary*, Nr. 74, Juni, S. 22–24 No. 74, June, pp. 22–24.
 Mark Durden, Willie Doherty, Non-Specific Threat, in: *Portfolio*, Nr. 41, Juni, S. 62–65 No. 41, June, pp. 62–65.
 Claudia Spinelli, Schreck, lass bloss nicht nach!, in: *Weltwoche*, Nr. 3, 20. Jan., S. 80f. No. 3, Jan. 20, pp. 80–81.

2004 Johannes Meinhardt, Recherche – entdeckt! Bildarchive der Unsichtbarkeit, in: *Kunstforum International*, Nr. 173, Nov./Dez., S. 379 No. 173, Nov./Dec., p. 379.

Michael Wilson, Willie Doherty, in: *Artforum International*, Mai, S. 209 May, p. 209.
Felicity Lunn, Zurich, in: *Contemporary*, Nr. 61, März, S. 23 No. 61, March, p. 23.
Peter Schneider, Willie Doherty. Galerie Peter Kilchmann, in: *Züritipp, Tages-Anzeiger*, 26. Feb., S. 52 Feb. 26, p. 52.
Daniele Muscionico, Kennzeichen: Angst, in: *Neue Zürcher Zeitung*, Nr. 37, 14./15. Feb., S. 52 No. 37, Feb. 14–15, p. 52.
Edgar Schmitz, Turner Prize 2003, in: *Kunstforum International*, Nr. 168, Jan./Feb., S. 372f. No. 168, Jan.–Feb., pp. 372–73.
Katrin Bachofen, Willie Doherty. Galerie Peter Kilchmann, in: *Handels Zeitung*, Nr. 4, 21. Jan., S. 31 No. 4, Jan. 21, p. 31.

2003 André Rogger, Mit matschigen Äpfeln, Goya und Pitbullterriern, in: *Tages-Anzeiger*, 9. Dez., S. 57 Dec. 9, p. 57.
 Juan de Nieves, Itinerario de la exposicion, in: *Papers de L'EACC*, Espai d'Art Contemporani, Nov./Dez., S. 7, 10f. Nov.–Dec., pp. 7, 10–11.
 Turner at 20, Tate, in: *Arts and Culture*, Nov./Dez., S. 46–53 Nov.–Dec., pp. 46–53.
 Adrian Searle, States of Decay, G2, in: *The Guardian*, 29. Okt., S. 12–14 Oct. 29, pp. 12–14.
 Fiachra Gibbions, But the real shock is … the Essex Vases, in: *The Guardian*, 29. Okt., S. 3 Oct. 29, p. 3.
 Morgan Falconer, Interview mit with Willie Doherty, in: *Contemporary*, Nr. 55, Sept., S. 30–33 No. 55, Sept., pp. 30–33.
 Jeffrey Kastner, Faith-Based Initiative, in: *Artforum International*. Sept., S. 96 p. 96.
 Aidan Dunne, Willie Doherty: False Memory, in: *Artnews*, Ausg. 102, Nr. 6, Juni, S. 128 Vol. 102, No. 6 (June), p. 128.

2002 Anthony Downey, Willie Doherty, in: *Contemporary*, April, S. 112 p. 112.
 Peter Suchin, Willie Doherty, in: *Frieze*, April, Nr. 66, S. 99f. April, No. 66, pp. 99–100.
 Magdalena Kröner, Formal social, in: *Kunstforum International*, Bd. 159, April/Mai, S. 36 Vol. 159, April–May, p. 36.
 Cherry Smyth, Willie Doherty, in: *Art Monthly*, März, S. 30f. March, pp. 30–31.

Louisa Buck, Remembering Bloody Sunday—and
all the rest, in: *The Art Newspaper*, Nr. 122, Feb.,
S. 18 No. 122, Feb., p. 18.

2001 Caoimhin Mac Giolla Léith, Willie Doherty: Kerlin
 Gallery, in: *Artforum International*, Feb., S. 164 p. 164.

2000 Peter Schneider, Fremd in der Stadt, in: *Züritipp,
 Tages-Anzeiger*, 15. Dez., S. 73 Dec. 15, p. 73.
 Katy Siegel, 1999 Carnegie International, in:
 Artforum International, Jan., S. 105f. pp. 105–06.
 Very New Art 2000: Willie Doherty, in: *Bijutsu Techo
 52*, Tokyo, Nr. 782, Jan., S. 108f. No. 782, Jan.
 pp. 108–09.

1998 Kathleen Magnan, Border Incident, in: *World Art,*
 Nr. 16, Frühjahr, S. 37–41 No. 16, Spring, pp. 37–41.

Arbeiten in öffentlichen und privaten Sammlungen (Auswahl)
Selected Public and Private Collections

Albright-Knox Art Gallery, Buffalo
FRAC, Champagne Ardennes
Dallas Museum of Art
Irish Museum of Modern Art, Dublin
Arts Council of Ireland, Dublin
The Israel Museum, Jerusalem
Arts Council of England, London
The British Council, London
The Imperial War Museum, London
Simmons & Simmons Collection, London
Tate, London
Weltkunst Foundation, London
Sammlung Goetz, München Munich
Solomon R. Guggenheim Museum, New York
Fonds National d'Art Contemporain, Paris
Vivendi Collection, Paris
The Carnegie Museum, Pittsburgh
Moderna Museet, Stockholm
Vancouver Art Gallery

Dank Acknowledgements

Ich möchte mich herzlich bedanken bei I would like to thank
Yilmaz Dziewior und and Matthias Mühling für Begeisterung,
Kenntnis und Humor for their enthusiasm, intelligence, and
good humour throughout this project; Corinna Koch, Meike Behm,
Eva Birkenstock, Katrin Vattes, Robert Görß und and Andreas
Krüger, Kunstverein in Hamburg; Helmut Friedel, Susanne Böller,
Karin Dotzer, Susanne Gaensheimer, Jonna Gaertner, Andreas
Hofstett, Felix Prinz und and Claudia Weber, Städtische Galerie
im Lenbachaus und Kunstbau, München Munich; Sue MacDiarmid
für ihre unschätzbare Unterstützung bei der Betreuung der
technischen Ausrüstung for her invaluable technical support;
Stephan Urbaschek, Sammlung Goetz, München Munich; Carolyn
Alexander, Ted Bonin und and Oliver Newton, Alexander and
Bonin, New York; John Kennedy, David Fitzgerald und and Darragh
Hogan, Kerlin Gallery, Dublin; Peter Kilchmann, Annemarie
Reichen und and Claudia Friedli, Galerie Peter Kilchmann, Zürich
Zurich; Robin Klassnik und and Joyce Cronin, Matt's Gallery,
London; Pepe Cobo, Galería Pepe Cobo, Madrid; Personal und
Studenten des MFA-Studiengangs the staff and students of
the MFA program und des and The Research Institute, University
of Ulster, Belfast, für ihre zuverlässige Unterstützung for their
continuing support; Francis McKee für seinen aufschlussreichen
Katalogbeitrag for his insightful text. Und schließlich gilt mein tief
empfundener Dank Finally, deepest gratitude to Angela Carlin für
nicht nachlassenden Rat und Unterstützung for her unwavering
support and advice sowie and to Joanna, Tomas, Eabha und
and Michael.

Willie Doherty

Diese Publikation erscheint anlässlich der Ausstellung
This catalogue is published in conjunction with the exhibition
Willie Doherty

19. Mai – 2. September 2007
May 19 – September 2, 2007
Kunstverein in Hamburg

29. September 2007 – 6. Januar 2008
September 29, 2007 – January 6, 2008
Städtische Galerie im Lenbachhaus und Kunstbau, München

Kunstverein in Hamburg
Klosterwall 23
20095 Hamburg
Deutschland Germany
Tel. +49 40 338344
Fax +49 40 322159
www.kunstverein.de

Kurator Curator Yilmaz Dziewior
Ausstellungskoordination Exhibition coordination Corinna Koch
Presse- und Öffentlichkeitsarbeit Press and public office
Meike Behm
Wissenschaftliche Assistentin Curatorial assistant
Eva Birkenstock
Praktikum Intern Katrin Vattes
Buchhaltung Bookkeeping Gesche Früchtenicht
Videotechnikerin Video technician Sue MacDiarmid
Leitung Ausstellungsaufbau Head of exhibition installation
Robert Görß
Kasse Cashiers Yilmaz Balkan, Kay Ruchholtz
Reinigung Cleaning Maike Nuppnau

Direktor Director Dr. Yilmaz Dziewior

Vorstand Board members Stephen Craig, Dr. Harald Falcken-
berg, Anna Gudjonsdottir, Prof. Dr. Susanna Hegewisch-Becker,
Dr. Ernst-Josef Pauw, Markus Peichl, Claudia Reiche, Jürgen
Vorrath, Dr. Hans-Jochen Waitz

Städtische Galerie im Lenbachhaus und Kunstbau, München
Luisenstrasse 33
80333 München
Deutschland Germany
Tel. +49 89 233 320-00
Fax +49 89 233 320-03
www.lenbachhaus.de

Kurator Curator Matthias Mühling
Assistenz Assistant Felix Prinz
Organisation Coordination Susanne Böller, Karin Dotzer
Videotechnikerin Video technician Sue MacDiarmid
Kommunikation Communication Claudia Weber, Jonna Gaertner
Technische Leitung Technical administration Andreas Hofstett

Direktor Director Helmut Friedel
Sekretariat Secretary Lore Thürheimer
Kommunikation Communication Claudia Weber, Jonna Gaertner
Kuratoren Curators Susanne Gaensheimer, Annegret Hoberg,
Matthias Mühling
Volontariat Assistant curator Felix Prinz
Restaurierung Conservation Iris Winkelmeyer, Daniel Oggenfuss,
Ulrike Fischer, Judith Ortner, Kristina Tost
Leihverkehr Loans Susanne Böller, Karin Dotzer, Karola Rattner
Fotoatelier Photo studio Simone Gänsheimer, Ernst Jank
Bibliothek Library Ursula Keltz, Dorothee Laar
Archiv Archive Irene Netta
Verwaltung Administration Kurt Laube, Sonja Schamberger,
Ursula Bauer, Irmgard Dinges, Beate Lanzinger, Yvonne Martin,
Monika Neumann, Barbara Schleicher, Elisabeth Wagner
Technik Technicians Andreas Hofstett, Klaus-Peter Henke,
Victoria Kerszt, Rainer Ketterl, Jörg Spies, Hermann Vorderegger

Katalog Catalogue

Herausgeber Editor Yilmaz Dziewior, Matthias Mühling
Redaktion Editing Matthias Mühling, Meike Behm
Lektorat Copyediting Dagmar Lutz (deutsch German),
Eugenia Bell (englisch English)
Videobeschreibungen Video texts Willie Doherty
Biografie, Bibliografie und Videografie Biography, bibliography,
and videography Meike Behm
Übersetzungen Translations Christopher Jenkin Jones
(deutsch–englisch German–English), Ralf Schauff
(englisch–deutsch English–German)
Grafische Gestaltung und Satz Graphic design and typesetting
Gabriele Sabolewski
Schrift Typeface AG Buch BQ
Reproduktion Reproductions Weyhing digital, Ostfildern
Papier Paper Nopacoat matt 150 g/m²
Druck Printed by E&B Engelhardt und Bauer Druck- und
Verlagsgesellschaft mbH, Karlsruhe
Buchbinderei Binding Industrie-Buchbinderei Schneider, Karlsruhe

Erschienen im Published by
Hatje Cantz Verlag
Zeppelinstrasse 32
73760 Ostfildern
Deutschland Germany
Tel. +49 711 4405-200
Fax +49 711 4405-220
www.hatjecantz.de
www.hatjecantz.com

Hatje Cantz books are available internationally at selected
bookstores and from the following distribution partners:
USA/North America – D.A.P., Distributed Art Publishers, New York,
www.artbook.com
UK – Art Books International, London, www.art-bks.com
Australia – Tower Books, Frenchs Forest (Sydney),
www.towerbooks.com.au
France – Interart, Paris, www.interart.fr
Belgium – Exhibitions International, Leuven,
www.exhibitionsinternational.be
Switzerland – Scheidegger, Affoltern am Albis,
www.ava.ch

For Asia, Japan, South America, and Africa, as well as for
general questions, please contact Hatje Cantz directly at
sales@hatjecantz.de, or visit our homepage www.hatjecantz.com
for further information.

ISBN 978-3-7757-1929-2
Printed in Germany

Bildnachweis Photo Credits

Fotos Photos Willie Doherty, außer except:
Alexander and Bonin, New York,
Foto Photo Jason Mandella: Seite page 149.
Douglas Hyde Gallery, Dublin,
Foto Photo Denis Mortell: Seite page 55.
Kerlin Gallery, Dublin,
Foto Photo Denis Mortell: Seite page 156–57.
Laboratorio del Arte, Alameda, Mexico City,
Foto Photo Magdalena Martinez-Franco: Seite page 127.
Laing Art Gallery, Newcastle-upon-Tyne,
Foto Photo Edward Woodman: Seite page 51.
Matt's Gallery, London,
Fotos Photos John Riddy: Seite page 83, 86–87, 97 (2), 121, 124–25.
The Renaissance Society, Chicago,
Foto Photo Tom van Eynde: Seite page 106–07.